IMAGES
of America
MARITIME SOUTH HAVEN
1900–1950

Roy S. McCrimmon
November 16, 1878–September 4, 1957

The photographs of maritime South Haven presented in this book are from the collection of Roy S. McCrimmon. Mr. McCrimmon, whose career as a real estate agent and insurance adjustor made an unquestionable impact on his career as a photographer, was a lifelong resident of South Haven. The McCrimmon family donated over 2,000 photos and negatives to the Michigan Maritime Museum in 1996. Examination of this collection shows an incredibly faceted body of work with a visual progression from amateur photography to more business-related images, while also providing photo-journalistic records and photo essays of his hometown. Mr. McCrimmon's photographs increased in clarity and sophistication over time as well. We are indebted to Roy S. McCrimmon for his foresight in capturing South Haven's early 20th-century history.

IMAGES of America
MARITIME SOUTH HAVEN
1900–1950

Michigan Maritime Museum

Copyright ©2004 by Michigan Maritime Museum
ISBN 0-7385-3314-9

Published by Arcadia Publishing
Charleston SC, Chicago, IL, Portsmouth NH, San Francisco, CA

Printed in Great Britain

Library of Congress Catalog Card Number: 2004111636

For all general information contact Arcadia Publishing at:
Telephone 843-853-2070
Fax 843-853-0044
E-mail sales@arcadiapublishing.com
For customer service and orders:
Toll-Free 1-888-313-2665

Visit us on the internet at http://www.arcadiapublishing.com

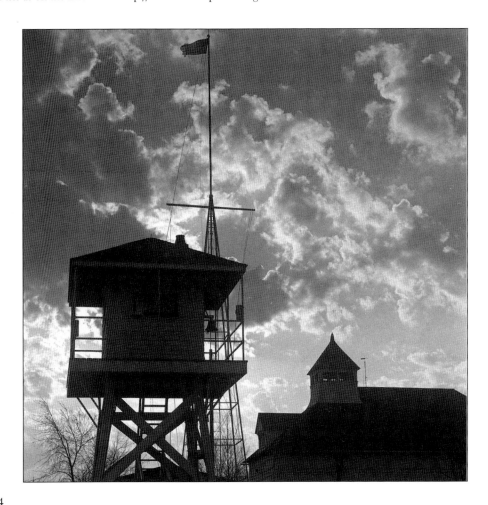

Contents

Acknowledgments 6

Introduction 7

1. Commercial Shipping 9
2. Passenger Ships 39
3. U.S. Life-Saving Service and U.S. Coast Guard 59
4. Recreational Boating 83
5. Commercial Fishing 99
6. South Haven Light and Piers 111

Acknowledgments

The Michigan Maritime Museum is grateful for the efforts of the following people—without their dedication and hard work, this book would not have been possible. Sheri Lemon, our computer guru, contributed her expertise in scanning images and providing technological advice. Museum Registrar Judith Allers Schlaack, a lifelong South Haven resident whose father was a commercial fisherman, shared invaluable in-depth knowledge. Research Assistant Ronnee Harrell did a bit of anything and everything that was asked of her. Martin Benacker, who knew Roy McCrimmon, was able to identify the activities in many of the photographs. Jean Overhiser, Ruby French, and Jane Merson Moore identified pictures with stories about South Haven's past. Dawn Eisner, intern for the Michigan Maritime Museum, contributed her practical writing skills. And the museum is also grateful to Marialyce Canonie, founder of the Research Library.

Many thanks to all,

Leslie A. Bleil
Librarian and Editor

INTRODUCTION

In the first half of the 20th century, South Haven was both very different and very similar to the town of today. A brief description of the town back then tells us that the streets were paved with brick and the sidewalks were concrete. The town is located at the mouth of the Black River. By the early 20th century it had electricity, water, sewers, and telephones. South Haven officially became a city in 1902. In 1906, a Carnegie library was built. The first hospital was built in 1907. There was a tannery, a fruit canning factory, and a basket factory, as well as sawmills and other industrial plants. Orchard farming was big business and a lot of fruit was shipped (some by boat) to Chicago. Many farms also doubled as resorts where city folk (often from Chicago) could breathe the country air.

By the 1930s, as a result of the Great Depression, most of the resort trade had shriveled. Blueberry farms were taking their place among the more traditional orchards of the past. The population was about 6,200 for both city and township. When commercial freighters started to be replaced by railroad and semi-truck shipping in the 1950s, the town "went to sleep" for a time.

In the early 1900s, industry played a big role, especially from a maritime perspective. Commercial shipping and commercial fishing kept the harbor active. Today, both are non-existent. Trucks replaced ships and the Lamprey eel wiped out the commercial fishing trade. However, just as they are today, resorts were plentiful and active a century ago. Recreational boating was popular in the past, but most of the boats were locally-owned and a high percentage of them were sail-powered. Today, recreational boating is the primary use of the harbor, and boaters come from all over the world. While sailing is still popular, powerboats dominate the marinas now.

In the early 20th century, we did not have the sophisticated technology of today. Therefore, busy harbors had to rely on people to provide a safety net. South Haven had an active light and lightkeeper and a busy U.S. Life-Saving Service, and later a U.S. Coast Guard station. Today, the light and keeper's house still stand, while the U.S. Coast Guard station is but a memory; the building itself burned down in 1989.

Today, due to increased travel by automobile, the resort trade is rebounding. Many tourists are also becoming part-time summer residents through second-home ownership. Both orchard and blueberry farming are doing well. South Haven is now known as the Blueberry Capital. The (year-round) population is roughly 5,000.

As the images in this book will show, South Haven's maritime activities have had a profound impact on the town, where the maritime influence can be seen in almost every aspect of life. The harbor began to develop when shipping accelerated the buying and selling of commodities. Additionally, the harbor, local countryside, and agriculture lured tourists. South Haven's proximity to Chicago brought more tourists, some of whom became semi-permanent residents. By the end of the 1950s, South Haven was well on the path of development upon which it

remains to this day.

Some of the captions in this book are direct quotes from Roy S. McCrimmon that he wrote on the back of the photos. There are a few images added to enhance the content of the book that are not from Mr. McCrimmon. The sources of these images are noted in their captions.

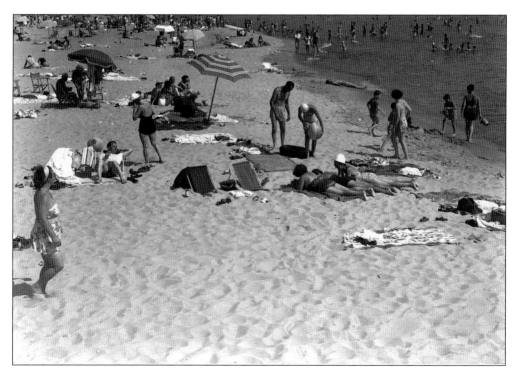

One
Commercial Shipping

Early 20th century South Haven was an important commercial port for southwestern Michigan. Beginning with the schooners and progressing to large freighters, a variety of commodities passed through the harbor.

Sawmills were busy, and since the immediate area was lumbered-out, schooners brought wood from northern Michigan. As the lumber came in, the fruit went out, as demand for the famous Haven peaches grew. Cherries were a big export as well. Sand and gravel were unloaded here for concrete production. Clay and paper pulp came in the 1920s, to make their way via rail to the paper mills of Kalamazoo. In the 1930s, foundries were established and the pig iron they needed was shipped in. Around that time, radios and pianos began being shipped out.

Coal was brought in for the city's power plant. It was simply dumped on the riverbank for various companies that had terminals in the harbor. These included the South Haven Terminal Company, H.W. Williams Transport Company, and Dunkley-Williams.

It was not unusual to see foreign ships at port in the 1940s and 1950s. A number of them were of Scandinavian registry, and there were also many from Canada. They brought primarily clay and paper pulp.

Many different types of commercial ships came to port here. The commercial shipping era began with wooden schooners and progressed to different types of steamships to whalebacks, steel freighters, and self-unloaders.

Due to the efficiency of commercial trucking, by the 1920s export commodities began to slip. By the 1940s, most Great Lakes commercial shipping consisted of raw materials—consequently, in South Haven there were no exports, only imports. Today, there are no commercial ships in our harbor and only the recreational boaters remain.

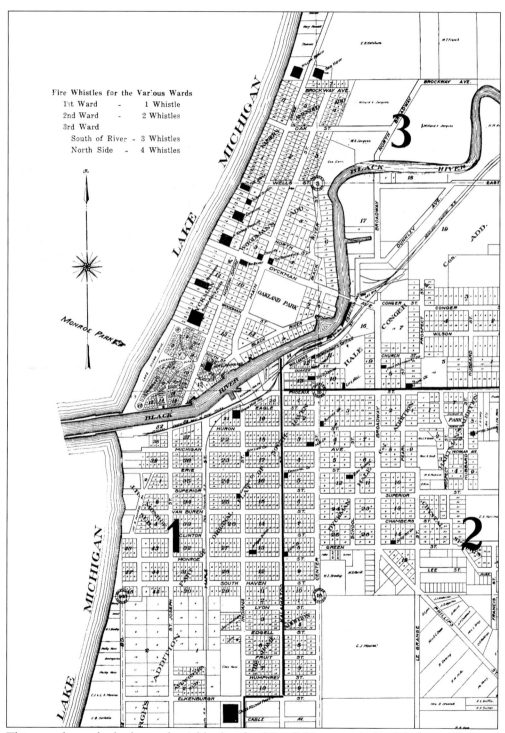

This map shows the harbor and neighborhoods of South Haven in 1904. (Michigan Maritime Museum Collection.)

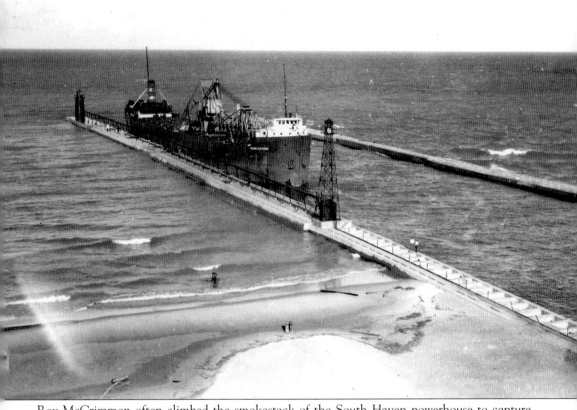

Roy McCrimmon often climbed the smokestack of the South Haven powerhouse to capture aerial images of the piers and incoming vessels. In this c. 1935 image, the bulk-carrier steamship *Colonel E.M. Young* (a 504-foot steel self-unloader of the United Steamship Company) enters the harbor, preparing to unload gravel or coal. Note the dimensions of the vessel in relation to the south pierhead light and range tower.

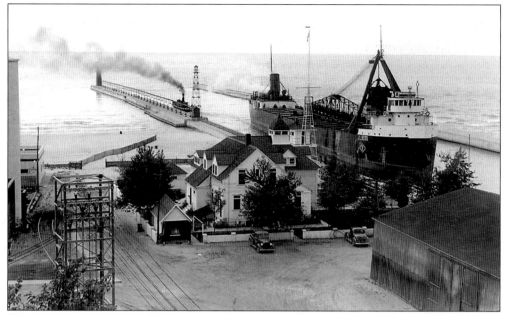

This image provides an excellent view of the outer South Haven harbor in the 1940s. The steel steamship *J.L. Reiss* towers over the U.S. Coast Guard Station as it is towed out of port after delivering a load of coal. The municipal power plant is visible at left, the U.S. Coast Guard Station is in the center, and the warehouse is at right. None of these exist today.

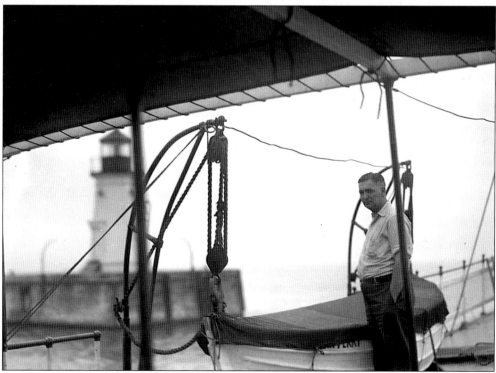

A crewman on a vessel from South Haven observes its entry into Chicago Harbor.

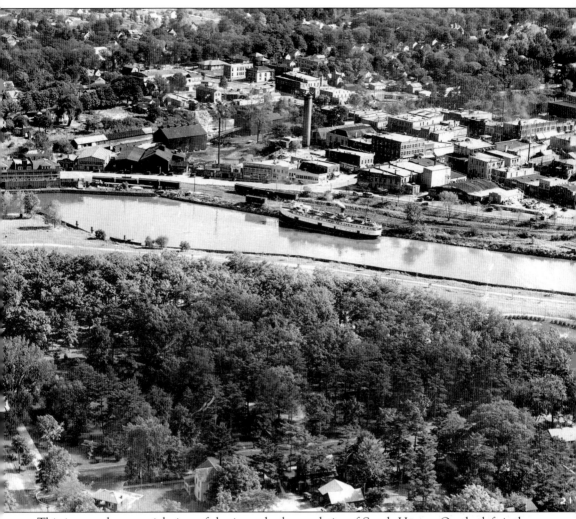

This is a southeast aerial view of the inner harbor and city of South Haven. On the left is the Chicago & South Haven Steamship Company terminal. Rail cars pause along the far edge of the river. The passenger steamship in view is docked at the foot of Center Street, the current location of Old Harbor Village Hotel and shopping district.

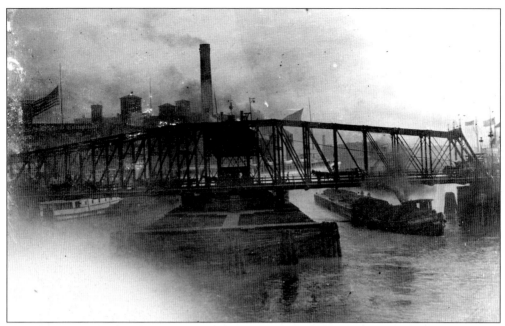

South Haven's first bridge across the Black River was a swing bridge. This view looks down towards Lake Michigan. Note the fish tug on the left and the barge on the right.

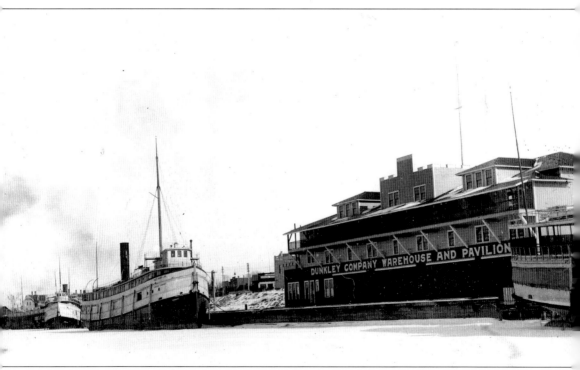

This image shows wooden passenger steamers and a schooner laid up for the winter at the Dunkley Company warehouse and pavilion on Williams Street.

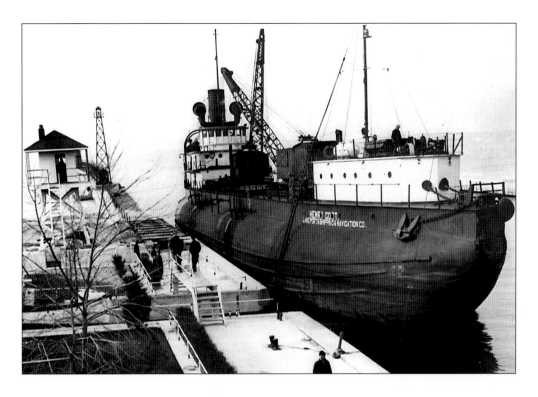

One of the few whaleback steamships to come to South Haven was the *Henry Cort* (Lake Ports Shipping and Navigation Company). The vessel arrived with a load of pig iron on November 28, 1934. Two days later, the *Cort* stranded on the Muskegon breakwater and sank. After breaking in half in December, she was declared a total loss and scrapped.

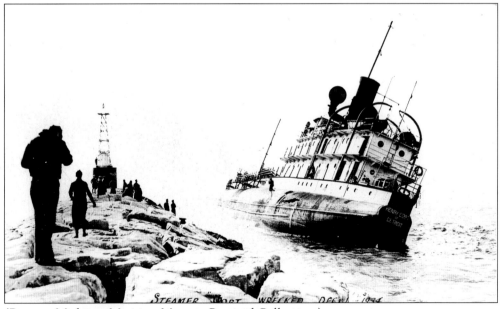

(Bottom: Michigan Maritime Museum Postcard Collection.)

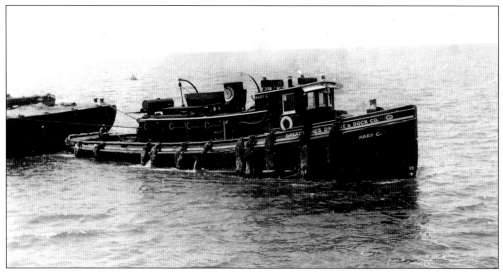

Tugboats such as the *Mary G.* (Great Lakes Dredge & Dock Company) often towed or assisted freighters and passenger steamships out of the South Haven harbor. More often, they moved barges, such as the one on the left of this picture.

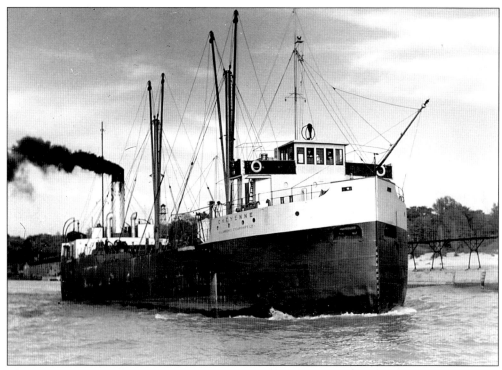

The steel Canadian freighter *Cheyenne*, of the St. Lawrence Steamship Company, departs South Haven in the 1930s. Riding high in the water, the vessel runs empty after unloading paper pulp. The *Cheyenne* was built in Great Britain in 1929. A state-of-the-art radio detection finder is mounted on the pilothouse. Also note the steering pole off the bow.

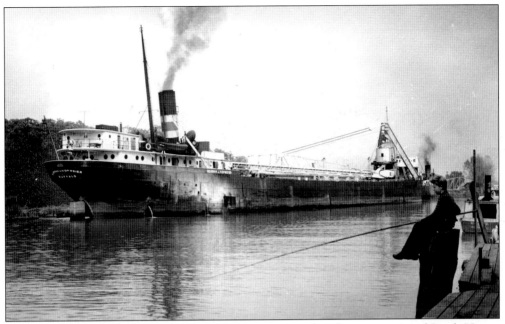

The self-unloading steamship *Norman J. Kopmeier*, moored at the current site of South Haven Municipal Marina, is pictured unloading coal in the 1940s. Note that another freighter ahead of the *Kopmeier* is unloading gravel at the present location of the Michigan Maritime Museum. The steam fish tug *Richard V* is visible to the right, docked on the south side of the river.

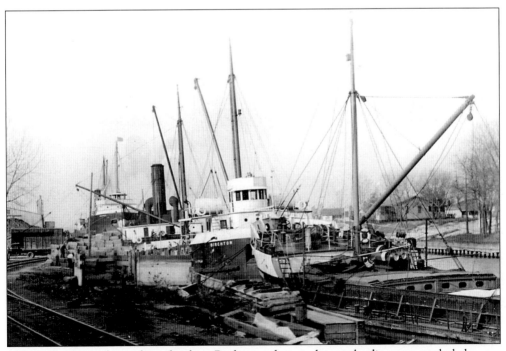

This image shows the package freighter *Birchton* and two others unloading paper pulp bales at a south side warehouse. The *Birchton*, a Canadian-registered vessel, was built in Scotland in 1924.

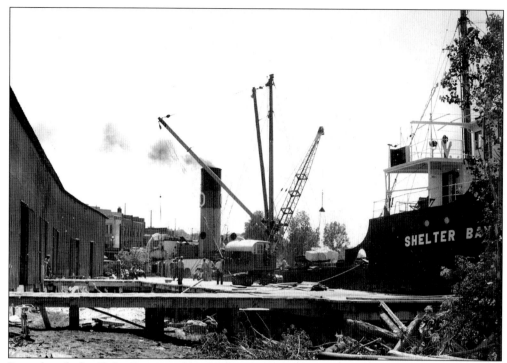
Even though the *Shelter Bay* was self-unloading, occasional use of a dockside crane was necessary.

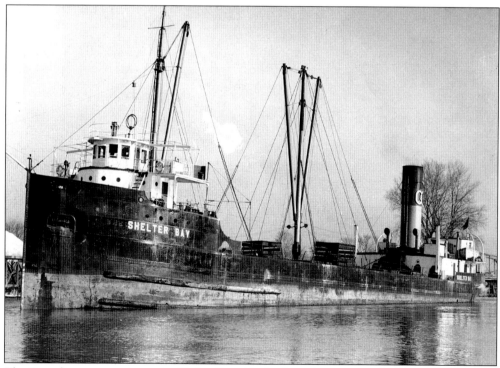
The Canadian paper pulp carrier *Shelter Bay* rides high in the water as she leaves empty. Built in Ireland in 1922, she was scrapped in 1961.

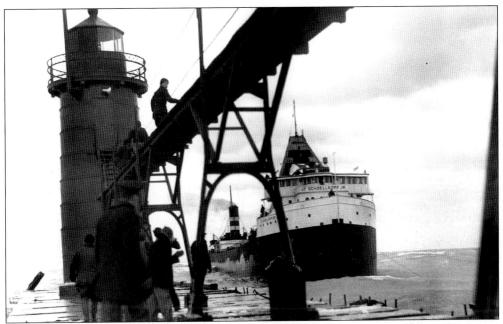

The self-unloading *J.F. Schoellkopf Jr.* enters the South Haven piers. The vessel, at 550 feet in length, is reported to be one of the longest ever to arrive in the harbor. Note the observers from the lighthouse catwalk, which is no longer open to the public.

The *J.S. Ashley* (Pioneer Steamship Company) is pictured leaving South Haven harbor after discharging its bulk cargo with self-unloading apparatus. The ship may have been carrying coal for the local power plant or gravel for concrete production. Built in 1909, the *Ashley* measured 524 feet long, with a 54-foot beam. She was the first self-unloader to load at the Northern Pacific Railway ore dock in Superior, Wisconsin.

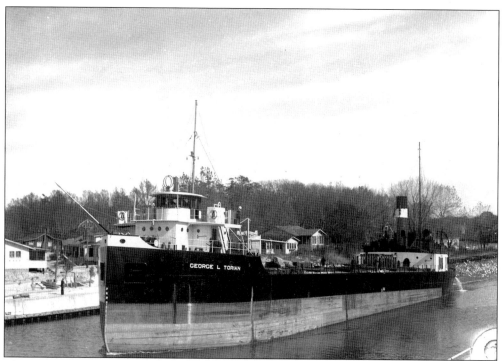

The Canadian ship *George L. Torian* departs South Haven.

The self-unloading *Robert J. Paisley* backs out empty. Her usual cargo was gravel. In 1960, South Haven's turning basin was enlarged to 440 feet. The 414-foot *Paisley* could then turn around.

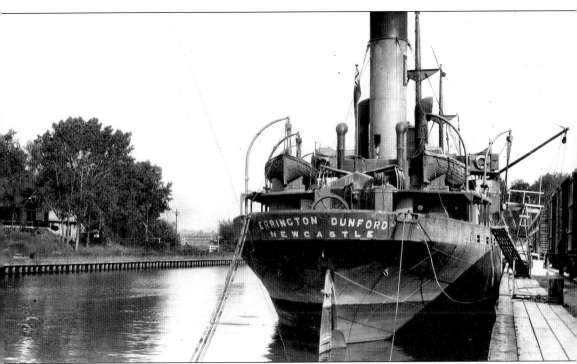

In 1925, the *Errington Dunford* was the first foreign ship to come to South Haven. She carried china-coating clay for the paper mills. Note that in this image she unloads directly into rail cars bound for Kalamazoo.

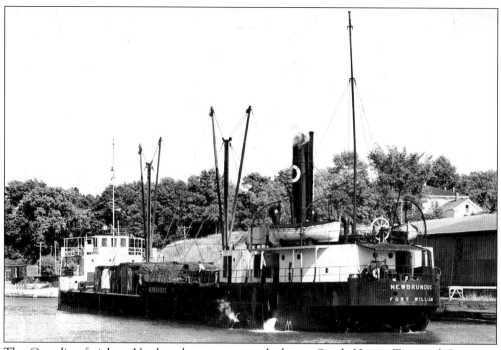

The Canadian freighter *Newbrundoc* prepares to dock at a South Haven Terminal Company dock on Water Street. Tarpaulins cover portions of the cargo, stowed on deck. The "doc" ending in the names of Canadian vessels stands for Dominion of Canada.

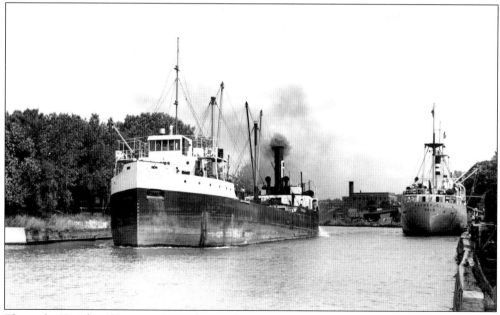

This is the *Troisdoc* of Paterson Steamships Ltd., Canada, leaving South Haven harbor. At 253 feet in length, she was barely able to turn around in the turning basin, where the limit was 260 feet. Now empty, she rides high in the water. After lumber disappeared, there was very little cargo to be shipped from South Haven for the freighters. The *Ravnefjell* of Oslo, Norway, is in the background.

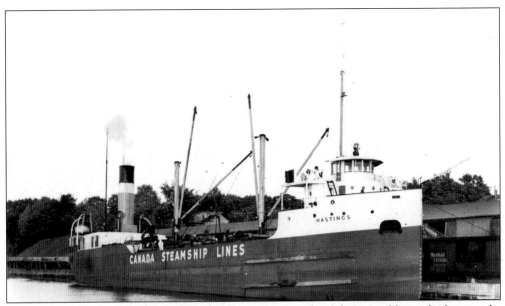

The package freighter *Hastings* has loaded her cargo onto the rail cars visible on the lower right of this image. This ship was originally launched as the U.S.S. *Wexford* for the U.S. Maritime Commission in 1945, but never served under the Navy and was christened *Pvt. Joe R. Hastings* in 1948.

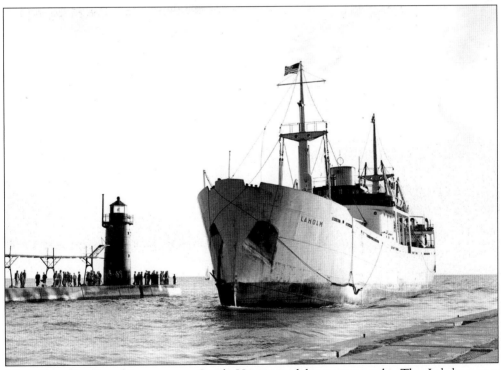

Many Scandinavian ships came to South Haven to deliver paper pulp. The *Laholm* was a frequent visitor.

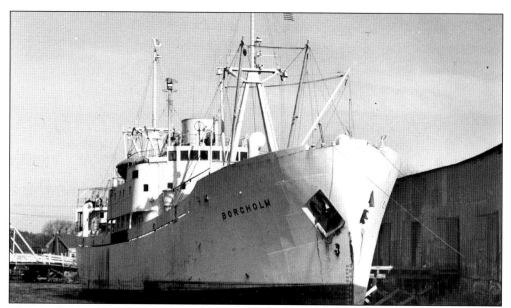

The *Borcholm*, another Scandinavian package freighter, is docked at the Williams Street warehouse of the South Haven Terminal Company. There, dockworkers unload pulp bales, which will then be sent to Kalamazoo paper mills. The old Dyckman Avenue swing bridge appears near the stern of the vessel.

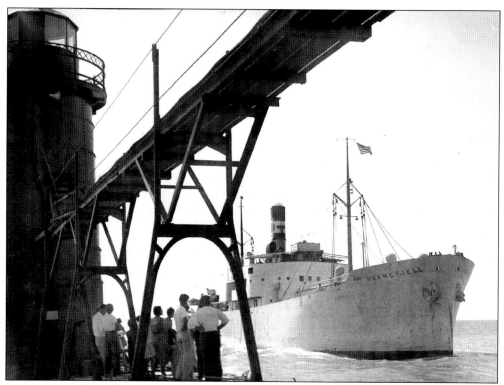

Spectators watch as the Scandinavian freighter, the *Svanefjell* of Norway, enters South Haven harbor. Such vessels, locally called "pulp boats," were a common sight in the harbor.

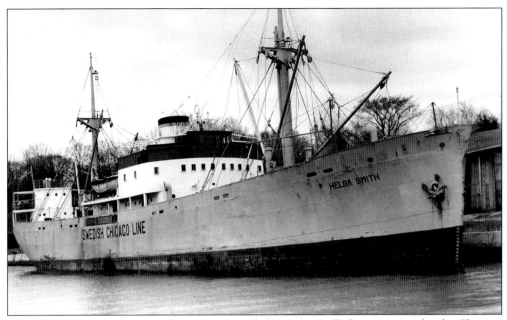

The *Helga Smith* was an annual visitor to South Haven, usually bringing wood pulp. She was abandoned off the coast of Newfoundland in April of 1963.

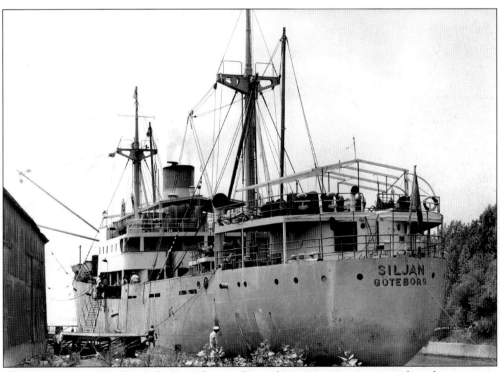

This image shows the Swedish ship *Siljan* as she undergoes maintenance work and inspection. This picture was taken prior to 1940, when the *Siljan* was torpedoed and lost in the North Atlantic. Notice how undeveloped the harbor was at the time.

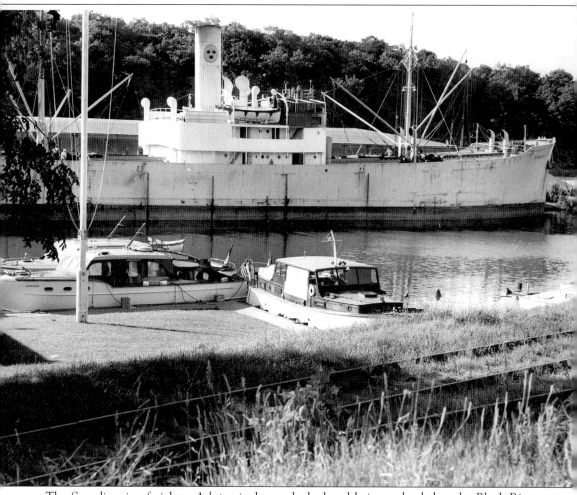

The Scandinavian freighter *Askepot* is shown docked and being unloaded at the Black River Street warehouse of the South Haven Terminal Company. On the opposite (near) side of the river are several cabin cruisers at the South Haven Yacht Club.

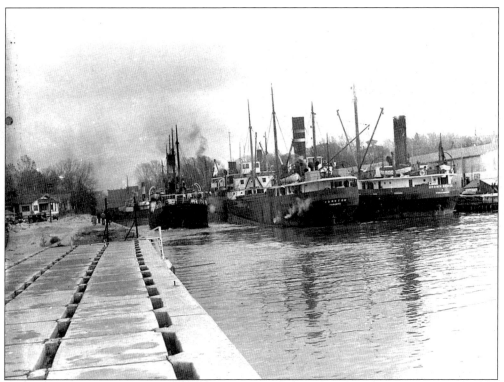
This image shows an international traffic jam on the Black River in the late 1930s. The *Yorkton* of Toronto is in the middle, with the Canadian ship *Brown Beaver* to her starboard.

Another lineup of ships (with names not distinguishable) appears on the north side of the harbor.

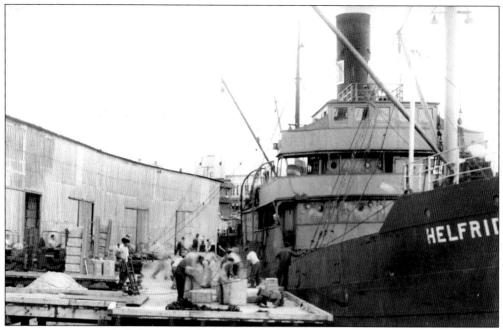

Unloading paper pulp bales required about 50 dockworkers per vessel. Men hired locally as stevedores assist with the unloading of paper pulp bales from a foreign vessel calling on South Haven.

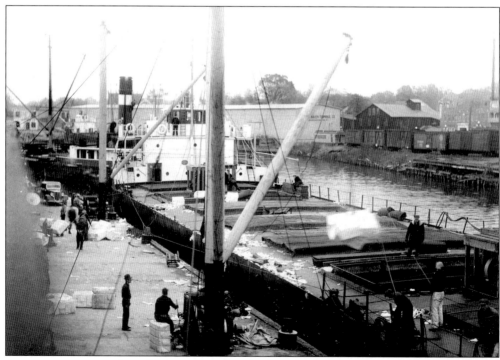

Anyone strong enough could get a day job unloading paper pulp. It usually took two days to unload a ship. The view looks east from the current All Seasons Marine.

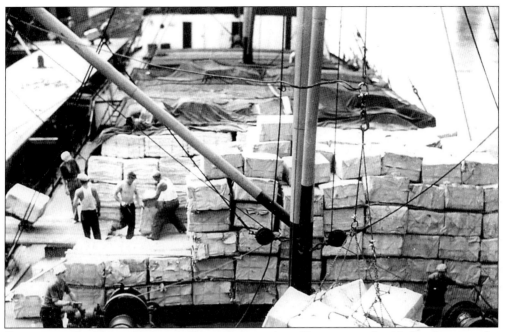
Crewmen on board a visiting steamship operate on-board booms to unload bales of paper pulp. Local men worked on shore unloading visiting vessels.

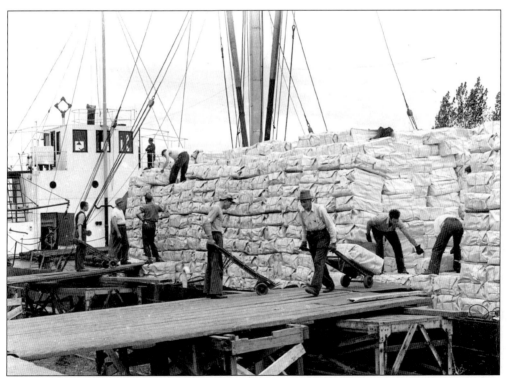
Unloading ships is backbreaking work. Men usually worked 14-hour days, from 7 a.m. to 11 p.m., handling 400–500 pound bales.

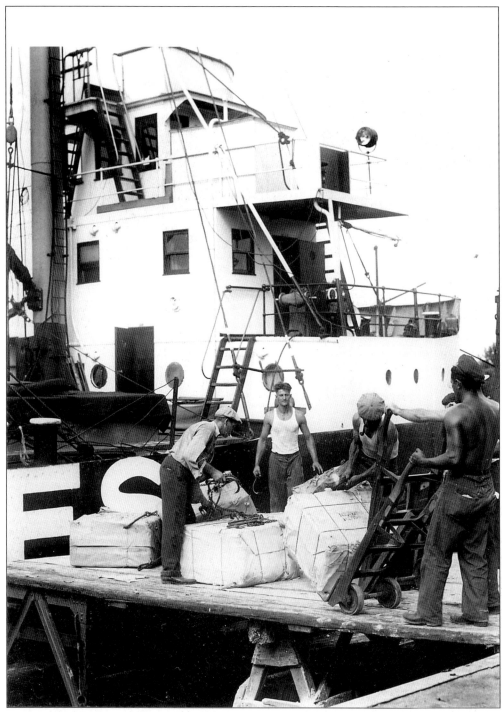
Dock work was also very dangerous. Men sometimes died or were severely injured when bales broke loose and fell on them.

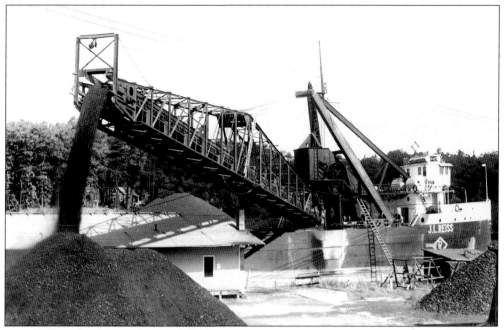

The 500-foot long *J.L. Reiss* discharges its cargo of coal with on-board unloading equipment. Coal and gravel were often deposited on the south side of the Black River, at the approximate location of the current South Haven Transient Marina. There were six coal terminals in South Haven in 1948, for self-unloaders only. The *Reiss* was built in 1906, and sank in 1972 in the St. Clair River, just south of the Blue Water Bridge, following a collision with the Canadian steamship *Parker Evans*.

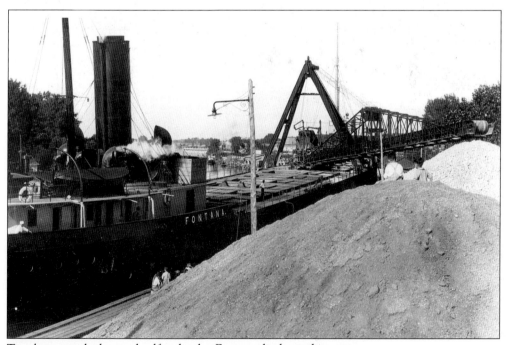

Two boys watch the steel self-unloader *Fontana* discharge her cargo.

31

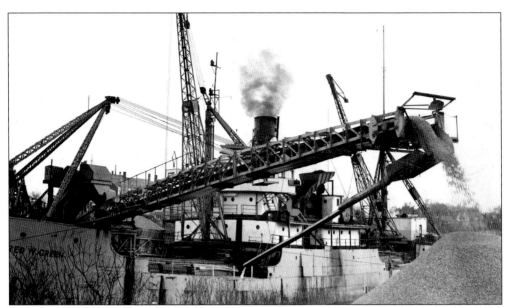

The self-unloading steamship *Fred W. Green* discharges gravel at a local concrete plant located at the current site of the Michigan Maritime Museum. This vessel was built in 1918 in Ecorse, Michigan. At 254 feet, she carried mostly crushed stone, sand, and gravel. Note the sluice draining water off the conveyor arm. A German submarine sank the *Fred W. Green* near Bermuda during World War II while the *Green* was sailing under British registry.

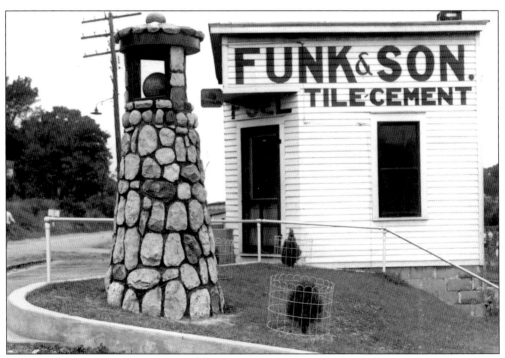

The Funk & Son Company used gravel brought in by freighters in their business. This unique stone lighthouse by their office can be seen today by those walking along the south side of the harbor.

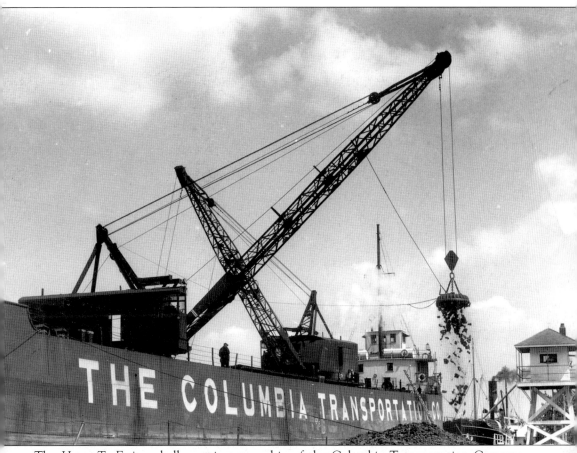

The *Harry T. Ewig*, a bulk-carrying steamship of the Columbia Transportation Company, unloads pig iron using on-board magnet cranes. After the ore was discharged onto the south beach, a portable crane, also using a large magnet, extracted the iron ore from the sand. The product was loaded into dump trucks and sent to the local foundry, National Motors Castings. Note the U.S. Coast Guard lookout tower nearby.

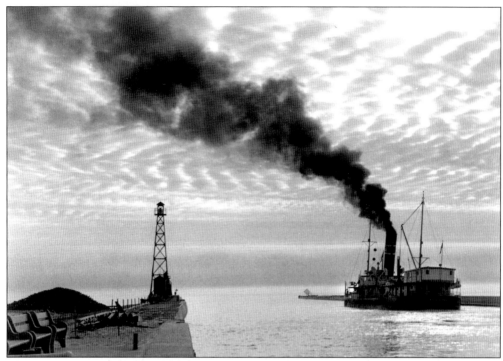

This image shows a dredge at work keeping the channel open. Notice the "mackerel" sky in the background.

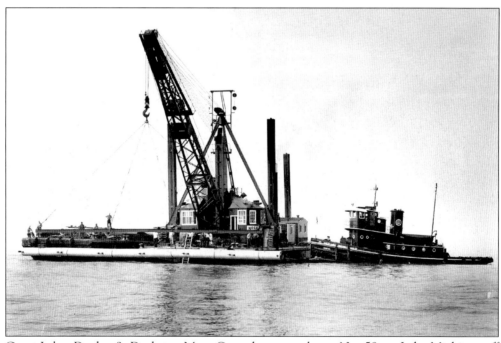

Great Lakes Dredge & Dock tug *Mary C.* pushes crane barge No. 58 on Lake Michigan off South Haven. The long pipe being carried by the barge may have been for use on the municipal water intake line.

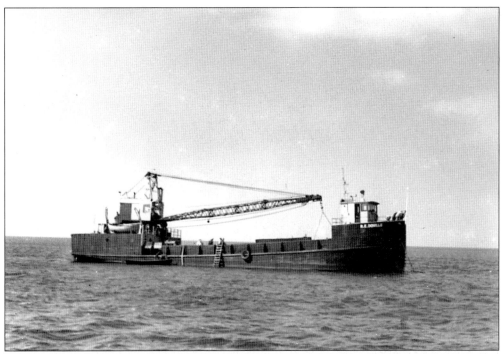

The *R.E. Doville* is seen anchored off South Haven during salvage operations.

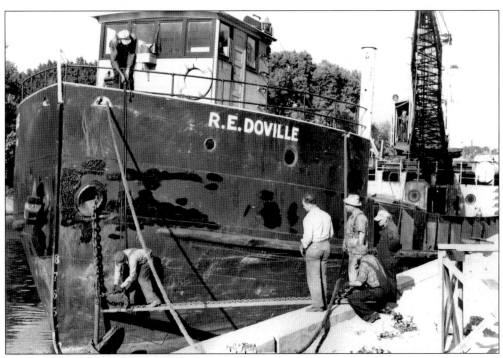

Crewmen work on the anchor and chain of the crane vessel *R.E. Doville*, working out of South Haven on salvaging the yacht *Verano*. A mysterious explosion and sinking of the luxury yacht north of South Haven killed several crewmen.

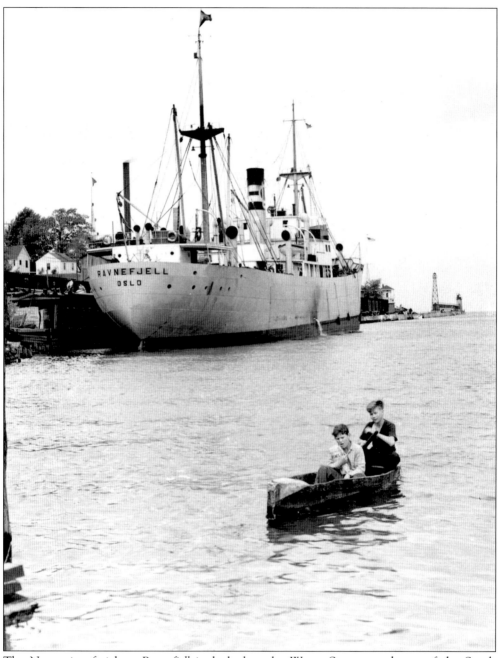

The Norwegian freighter *Ravnefjell* is docked at the Water Street warehouse of the South Haven Terminal Company, unloading paper pulp. Two boys explore the vessel and the Black River in their primitive canoe. Uphill from the docks the lightkeeper's dwelling, then in use as housing for the senior officer of the U.S. Coast Guard Station, can be seen. The *Ravnefjell* survived numerous terrifying World War II Atlantic crossings, carrying TNT, as well as other explosives. In 1950, she collided with the passenger steamship *City of Cleveland* off Harbor Beach, Michigan. Five passengers on the American vessel were killed in the accident.

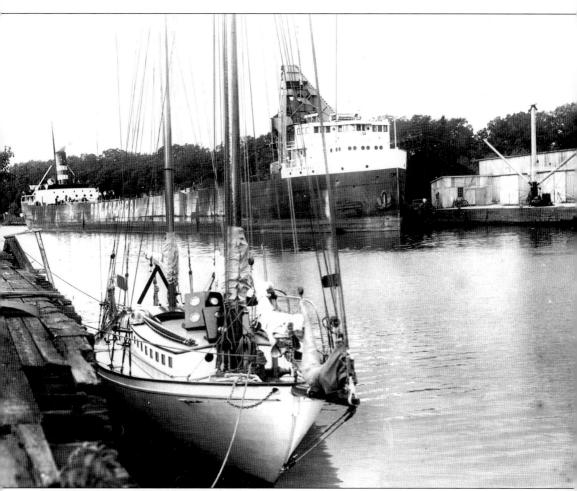
Commercial and recreational vessels share the harbor.

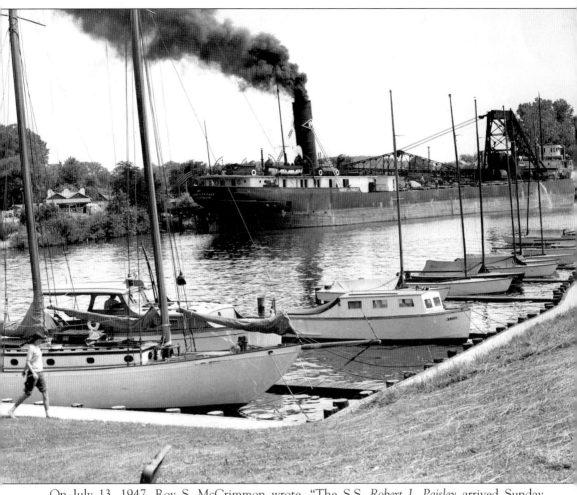

On July 13, 1947, Roy S. McCrimmon wrote, "The S.S. *Robert J. Paisley* arrived Sunday morning with a load of crushed stone on the north side of the Black River, just east of the South Haven Yacht Club's mooring slips."

Two
Passenger Ships

Before the mass-production of the automobile or development of our nation's highway system, travelers near Lake Michigan found it quickest and cheapest to get around by ship. During the summer season, hundreds of people went back and forth across the lake daily to numerous ports by passenger steamer. South Haven was a popular destination for vacationers, many from the Chicago area, looking for fun and fresh country air. There was a lot to attract the tourist, from beaches and the lake to casinos, amusement parks, and dance halls. From 1913 to 1916, South Haven held its own Chautauquas, weeklong meetings of public lectures and entertainment under a large tent.

Many of the local resorts back then were large affairs, unlike the bed and breakfasts of today. They would send their own wagons or river launches to meet the steamers in order to pick up guests and luggage. Often times, fruit and mail would be shipped back, along with contented vacationers returning home.

Competition for the travelers' business was fierce. In 1903 the Dunkley-Williams Company launched the S.S. *City of South Haven*, nicknamed the "White Flyer," which could carry roughly 2,000 passengers and sleep 400. She could cross the lake at the great speed of 20 miles per hour.

Built to compete with the *City of South Haven* was the infamous *Eastland*. The *Eastland* could carry a similar number of passengers and the two boats often raced across the lake between 1903 and 1908. In 1915, the *Eastland* capsized in Chicago Harbor and over 800 lives were lost.

Following in the wake of the wooden steamers and side-paddle steamers were the steel steamships like the *Iroquois* and the *Theodore Roosevelt*. Equipped with wireless telegraph and other modern devices, these ships made crossing the lake faster and even more luxurious.

World War II, coupled with the volume and decreasing cost of automobiles, spelled the demise of the elegant passenger steamer. It is a shame that this wonderful mode of travel cannot coexist with our need to get places in a hurry.

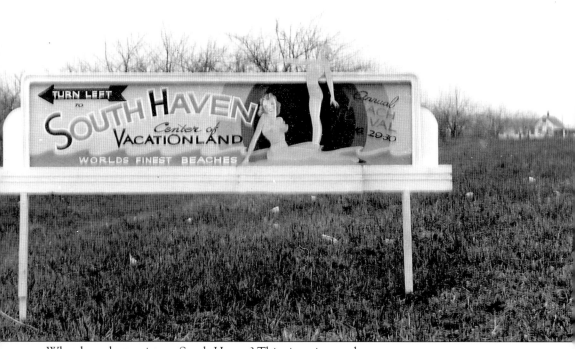

What brought tourists to South Haven? This sign gives a clue.

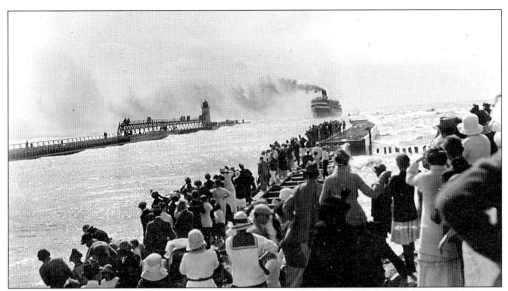

Crowds gather on the South Haven piers, awaiting the arrival of the passenger steamer *City of South Haven*.

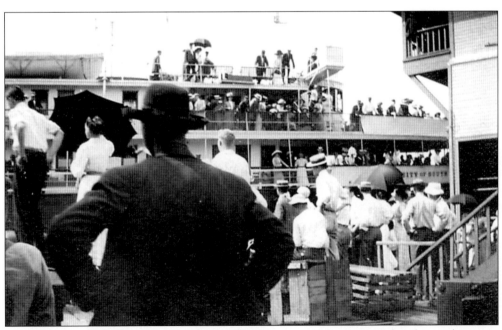

In addition to passengers, the *City of South Haven* was an important conduit for southwestern Michigan's fruit on the way to Chicago. She also carried the U.S. Mail.

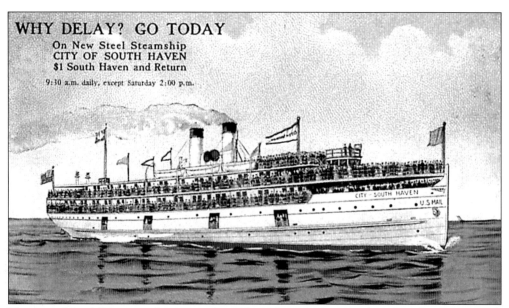

The *City of South Haven* was known as the "White Flyer" for her speed on the Chicago to South Haven run. (Michigan Maritime Museum Postcard Collection.)

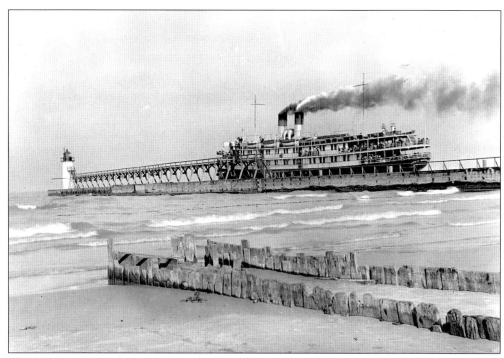

The passenger steamship *City of South Haven* departs with a full load of travelers. Although the piers are still wooden at this time, the new steel light tower has been installed.

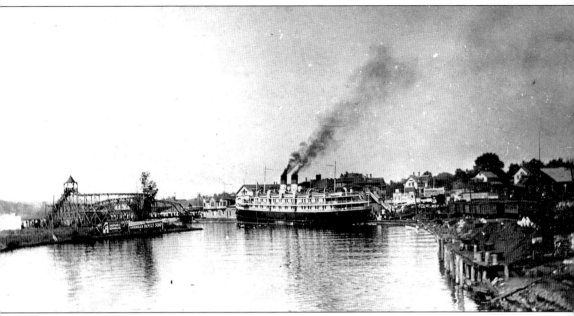

The passenger steamship *City of South Haven* is seen departing her dock and turning in the basin for her trip to Chicago. On the left is the Chautauqua tent and a roller coaster, near the current site of the Michigan Maritime Museum. Further upriver the steel swing bridge on Dyckman Avenue can be seen.

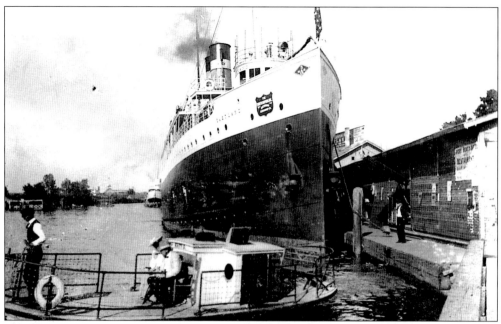

The ill-fated passenger steamer *Eastland* was launched in South Haven in 1903 to compete with the *City of South Haven*. The two ships often raced between Chicago and South Haven. *Eastland* capsized in Chicago Harbor in 1915 and more than 800 lives were lost.

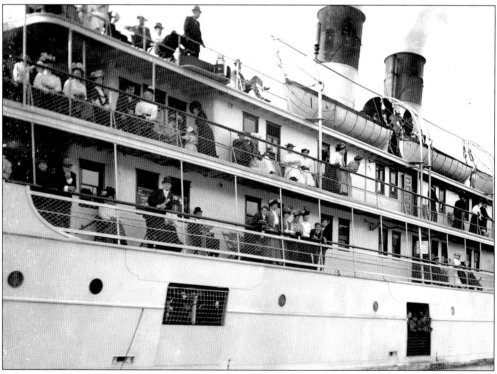

An arrival or departure brought passengers to the railings to observe the activities on the dock. Note the people at the below-deck hatches watching as well.

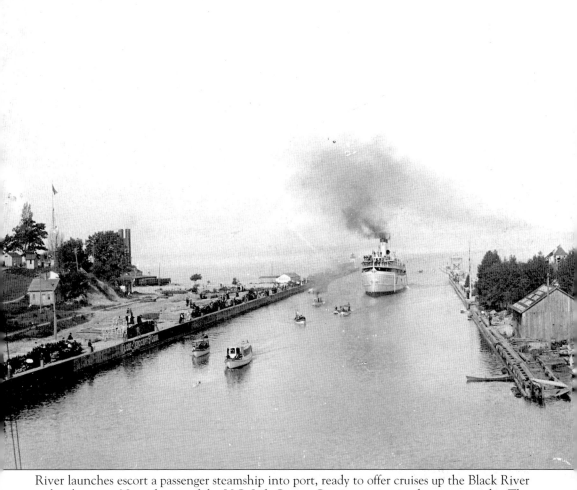

River launches escort a passenger steamship into port, ready to offer cruises up the Black River to local resorts. Note the tip of the U.S. Life-Saving Service station in the trees at right. The station was later moved by barge across the river. The only remaining building from the station is now at the Michigan Maritime Museum.

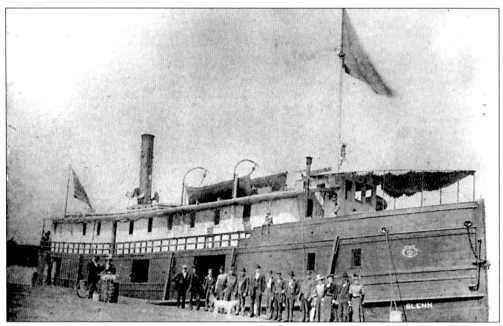

The steamer *Glenn* was built in South Haven in 1889. She plied the west coast route carrying passengers and diverse cargoes of pickles, fruit, and other items. She sailed the South Haven to Chicago run frequently. In 1903, she was overhauled and remodeled so she could carry up to 600 passengers.

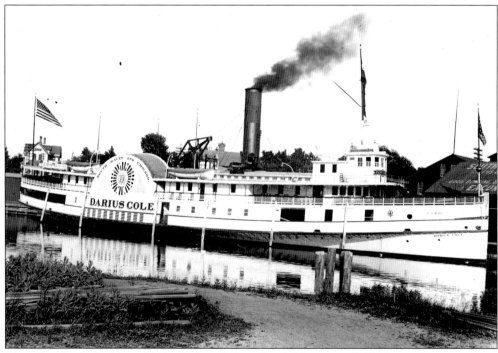

The side-wheeled steamer *Darius Cole* called on South Haven until 1906, carrying passengers, cargo, and U.S. Mail. She was part of the South Haven & Chicago Line.

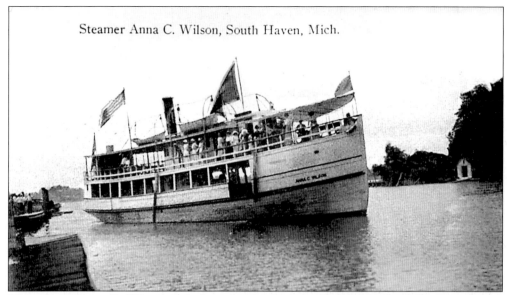

The steamer *Anna C. Wilson* was built in Saugatuck in 1912. A dainty ship of 91 feet, she was contracted to take fruit from Lake Michigan piers to South Haven, and then to connect with the Dunkley-Williams boats to Chicago. She was also used for charters and excursions. In 1915, she received a new engine which allowed her to ply the South Haven to Chicago trip herself. In 1917, an elevator was installed since she had begun exporting pianos from South Haven's Everett Piano Company. She was abandoned in 1942. (Michigan Maritime Museum Postcard Collection.)

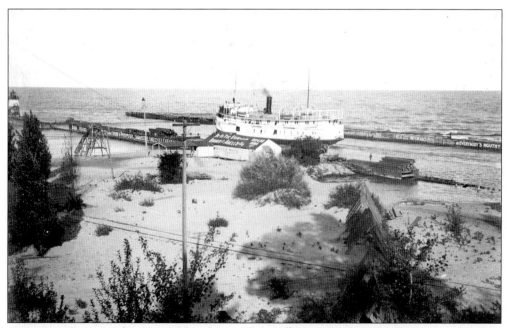

A passenger steamship, possibly the *H.W. Williams*, departs South Haven Harbor. Advertisements, including ones for Niffenegger Bros. and Van Ostrand's Pharmacy, are painted on the still-wooden piers. Note a lumber barge to the right of the steamer.

South Haven Steamers
"The Safest Way"

STEEL STEAMSHIP
IROQUOIS
DAILY BETWEEN CHICAGO AND
SOUTH HAVEN

MICHIGAN'S FAMOUS SUMMER RESORT

A DELIGHTFUL RIDE ON

<u>NO DUST</u> LAKE MICHIGAN <u>NO DIRT</u>

A MODERN STEEL STEAMER

Equipped with wireless telegraph and all other modern devices for the safety and comfort of passengers.

235 feet in length, 35 foot beam, 49 state rooms and 2 bridal parlors, with steam heat, running water and electric lights. A spacious dining room 35x40 feet, with excellent cuisine prepared in the modernly equipped kitchen. No effort has been spared to provide every comfort of the home in furnishings and service.

The engines and boilers are of the most powerful, modern type, enabling this steamer to maintain a high rate of speed with the utmost safety.

Chicago & South Haven Steamship Co.

Before the advent of automobiles and a good highway system, the most common form of transportation between South Haven and Chicago was by passenger steamships such as the *Iroquois*. Barrels of fresh fruit were loaded for the return trip to Chicago. (Michigan Maritime Museum Collection.)

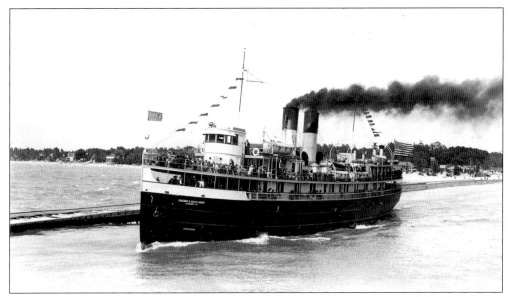

The *Iroquois*, of the Chicago and South Haven Steamship Company, is pictured on her way to Chicago. The advertisements boasted she was the most direct route from Chicago to South Haven, Kalamazoo, Battle Creek, and other cities. She docked at the south end of the Clark Street Bridge.

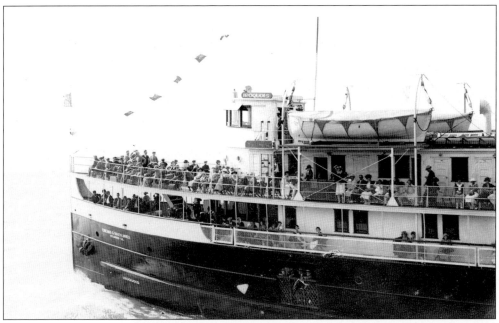

The steel passenger steamship *Iroquois* was equipped with wireless telegraph and other modern devices. She ran between South Haven and Chicago daily from 1920 to 1927.

1874 GOLDEN ANNIVERSARY 1924
The Graham & Morton
G&M LINE Transportation Company

Pass J.E. Gorman, Pres.,
C. R.I. & P. Ry. Co.

UNTIL DECEMBER 31ST

No. 179

J S Morton
PRESIDENT

This is an annual corporate pass for travel on the steamer *City of Benton Harbor*. (Michigan Maritime Museum Collection.)

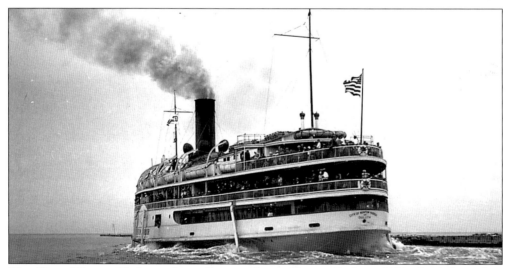

The *City of Benton Harbor* is shown leaving South Haven. Built in 1904, she belonged to Graham & Morton Transportation Company until 1924; she later became part of the Goodrich Transit Company. The vertical object hanging amidships into the water is a dock bumper.

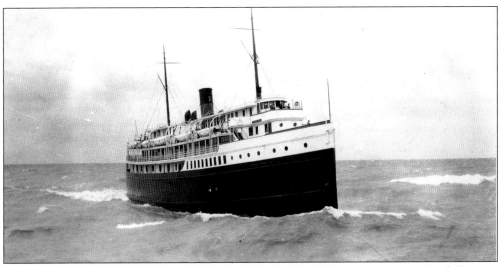

Pictured here is the passenger ship *Carolina* of the Goodrich Transit Company, South Haven.

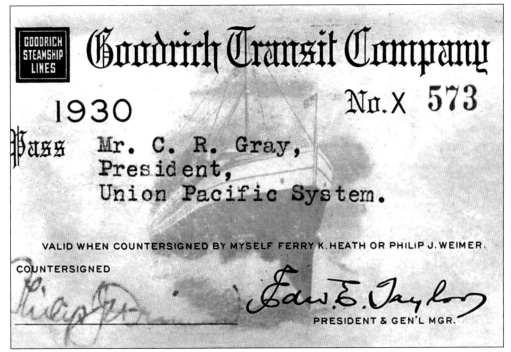

This is an annual pass for the Goodrich Transit Company. (Michigan Maritime Museum Collection.)

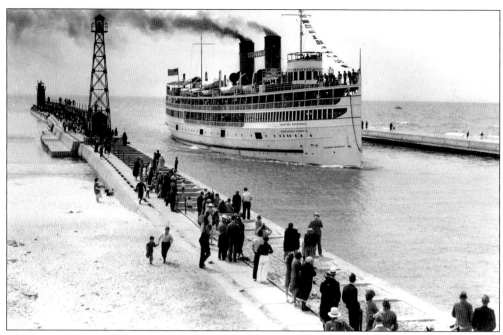
The passenger steamer S.S. *Theodore Roosevelt* arrives in South Haven.

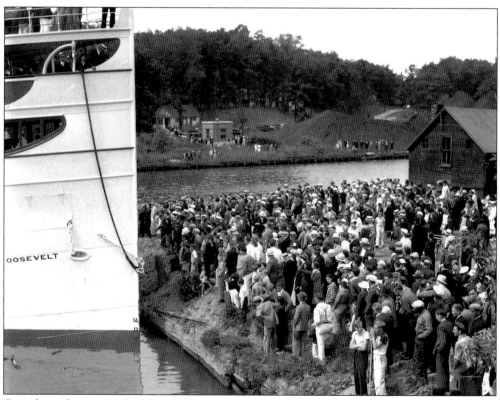
Crowds on the river's edge observe the passenger steamship S.S. *Theodore Roosevelt* as she noses into a slip to turn around.

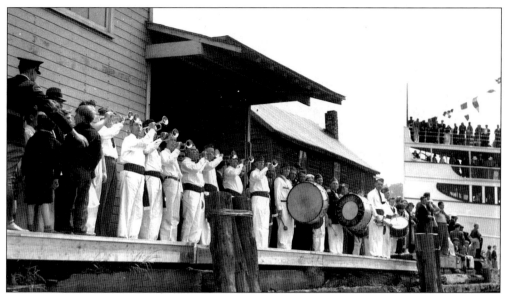

A brass band from the South Haven VFW post greets incoming tourists. The S.S. *Theodore Roosevelt* is on the right.

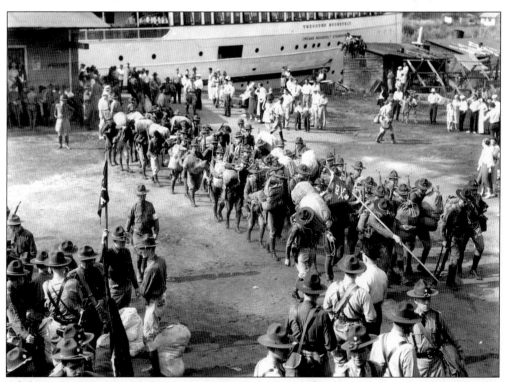

Of this scene, Roy S. McCrimmon wrote, "S.S. *Roosevelt* unloaded, in two trips, Saturday August 8th at South Haven. 3600 members of the Illinois National Guard of the 33rd Division en route to Pearl, Allegan County. Hundreds of South Haven citizens welcome the soldiers at 5 a.m. and again at 4 p.m." The year was 1936 and the Guardsmen were participating in war games in Allegan County.

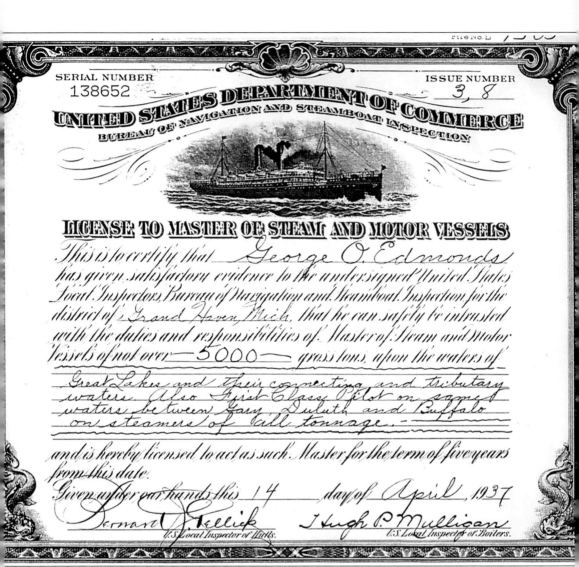

Being granted a Master's License was no easy feat. Most men worked their way up from lower positions first. Testing for the South Haven area was done in Grand Haven. (Michigan Maritime Museum Collection.)

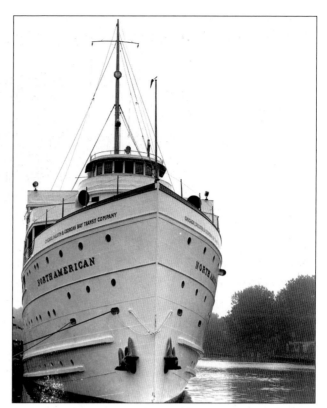

These images depicts a rare visit to South Haven by the luxury cruise ship *North American*. She and her sister ship, the *South American*, were considered the "ocean liners of the Great Lakes."

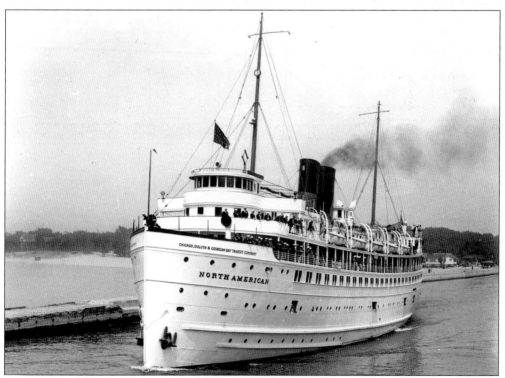

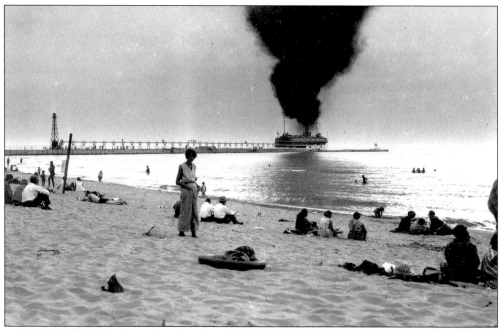

A black smudge announces the departure of the *North American* from South Haven. The air pollution that belched out of these steamers isn't often mentioned. South Haven's north beach looks much the same today as it did when this photograph was taken.

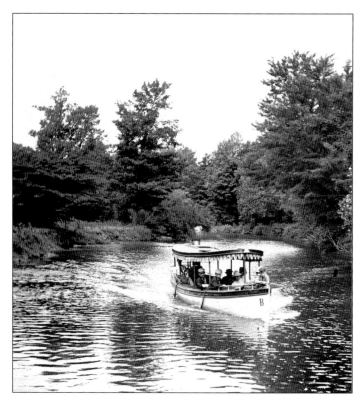

Arriving tourists are picked up by a resort launch for transport up the Black River for a week or weekend vacation.

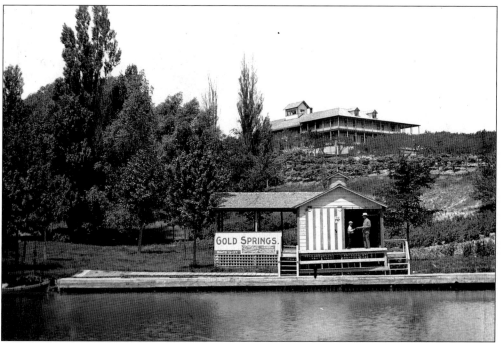

This is Gold Springs Resort dock where river launches tied to embark and debark guests. Notice the sign that mentions boats to rent.

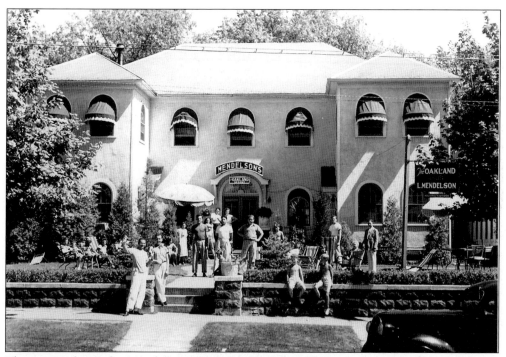

This image shows the Mendelson's Resort on North Shore Drive near the river. (Michigan Maritime Museum Collection.)

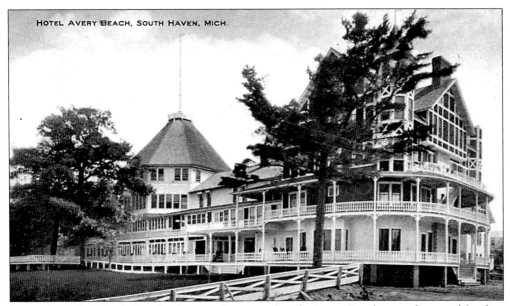

Located on the North Beach, the popular resort hotel, Avery Beach, was destroyed by fire. (Michigan Maritime Museum Postcard Collection.)

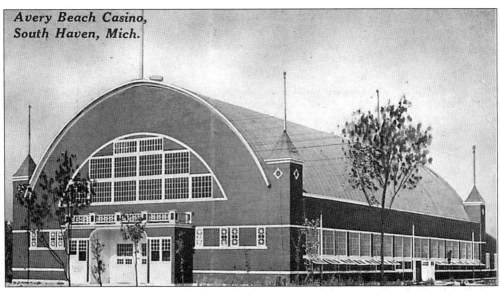

In 1912–1913, the Big Casino was built on the former site of the Avery Beach Hotel. Billed as one of the largest covered dance halls in the country, this structure burned as well, in 1937. (Michigan Maritime Museum Postcard Collection.)

Three

U.S. Life-Saving Service and U.S. Coast Guard

The U.S. Life-Saving Service went into commission in South Haven on February 11, 1887. It was located on the north side of the Black River. Due to a rotting foundation, in 1908 the station was moved by barge to the south side of the river, where it remained until it burned. The lookout tower on the north pier was built in 1903.

Five captains served the U.S. Life-Saving Service in South Haven. Their names and years of service are: Barney Alonzo Cross (1887); John H. McKenzie (1888–1893); Lew G. Matthews (1893–1903); Peter Jensen (1903–1904); and Frank E. Johnson (1904–1918). In addition to the captain, there was a crew of seven men.

In 1915, during the tenure of Captain Johnson, the U.S. Life-Saving Service was merged with the Revenue Cutter Service to create the U.S. Coast Guard. The responsibilities of the station included keeping watch over the harbor 24 hours a day. Watch shifts were two hours in length. Station members also did beach patrols, which began at 8 p.m. each evening and lasted throughout the night. Patrols went two miles north and two miles south along the beach.

The weekly routine at the station included the following: beach practice on Monday and Thursday with the breeches buoy; boat practice on Tuesday; flag practice on Wednesday; life support practice on Thursday; and cleaning of the station house and grounds on Saturday. Other activities included giving demonstrations of the breeches buoy and an exhibition for the crowds who came for the Fourth of July holiday.

The station was usually open from April through November, when the crew went out of commission for the year. A three-man crew wintered in the lightkeeper's dwelling from 1936 to the 1950s. By this time there were three boats in use: a 36-foot motor lifeboat, a surfboat, and an ice skiff.

When the U.S. Life-Saving Service became the U.S. Coast Guard in 1915, other duties besides search and rescue were assigned as well. These included: law enforcement, ice breaking, environmental protection, preventative safety, and augmenting the Navy (in wartime). The South Haven station's primary duties were search and rescue along with preventative (i.e. boating and swimming) safety. The Lighthouse Service was merged into the U.S. Coast Guard in 1936, which designated the light and keeper's dwelling as responsibilities of the U.S. Coast Guard.

U.S. Coast Guard Station No. 272 was manned until 1972, when all personnel were transferred. It was deactivated in 1973 and reactivated in 1974 as a Coast Guard Auxiliary post with no assigned active duty personnel. On February 7, 1989, the station was badly damaged by fire, and the decision was made to raze the building. The site is now part of a park-like area for visitors.

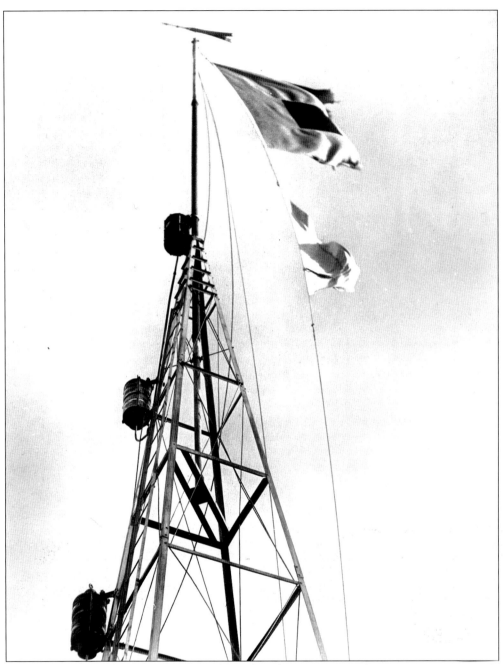
This is a standard signal tower that could be found at any U.S. Life-Saving Station or U.S. Coast Guard Station around the Great Lakes. Station personnel flew flags that warned mariners of dangerous weather. Later, when electricity was installed, lights were added. This tower is the only structure remaining on the site of the U.S. Coast Guard Station in South Haven.

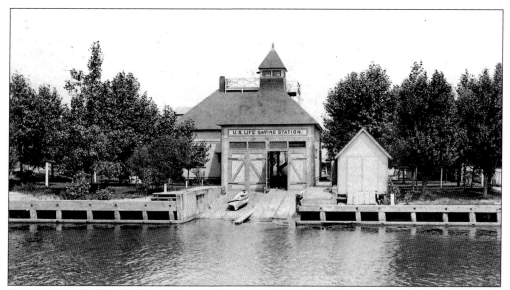

Construction on the U.S. Life-Saving Station on the north side of the Black River began in 1885, was completed on February 7, 1887, and was accepted by the government on February 11, 1887. It was a Bibb No. 3 style, designed by the U.S. Life-Saving Service architect Albert B. Bibb. Eighteen years later, discussions began about moving the station to a more suitable location due to the foundation deteriorating. The U.S. Government later moved the buildings across the river.

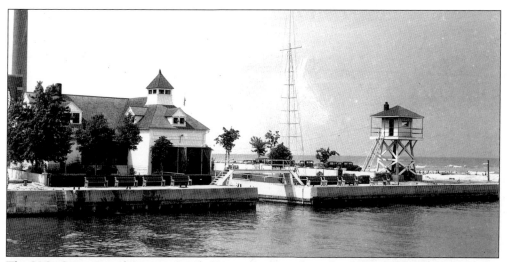

The U.S. Coast Guard Station South Haven is pictured on the south side of the harbor. On June 26, 1908, contractors from Benton Harbor moved the station, then the U.S. Life-Saving Service, across the river. It was placed on a new concrete foundation, which provided room for a basement. The main building was destroyed by fire in 1989. An outbuilding, relocated to the Michigan Maritime Museum, currently serves as part of the U.S. Life-Saving Service/U.S. Coast Guard exhibit. The signal tower remains on the site of the station. At the far right of this image is the observation tower. According to long time resident Marty Benacker, "The boys used to stand watch there and patrol the beach at night. Those on duty in the tower would ring bells at the change of the watch."

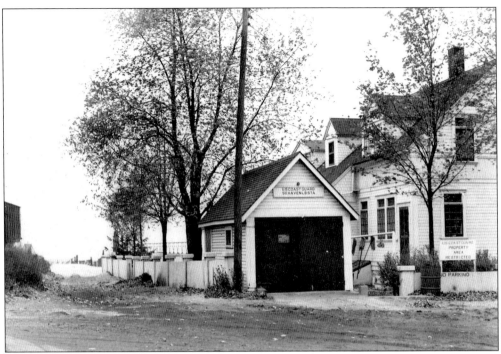

This image shows the garage and back side of the U.S. Coast Guard Station South Haven. The facility was very well kept and maintained.

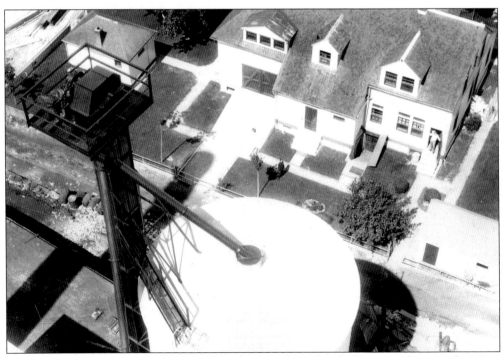

An aerial view of the U.S. Coast Guard Station in South Haven. Photographer Roy McCrimmon often ascended the stairs on the powerhouse smokestack for his shots.

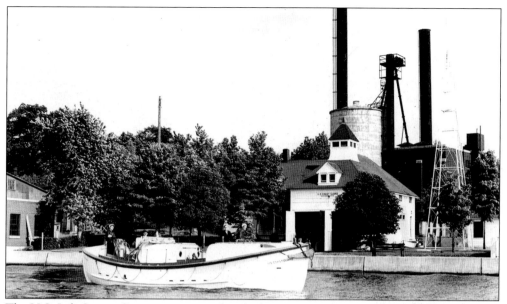

The U.S. Life-Saving Service was merged with the Revenue Service in 1915 and later became the U.S. Coast Guard. Here, a 36-foot motor lifeboat (MLB) is on patrol with a three-man crew near the station. The municipal powerhouse is behind the U.S. Coast Guard grounds.

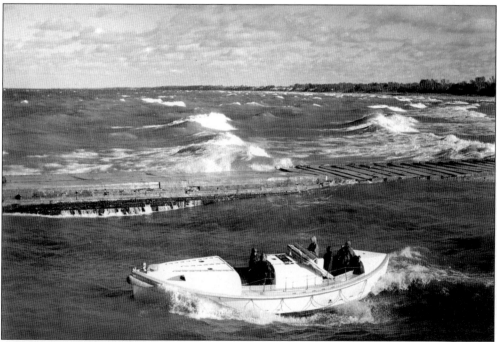

With the arrival of the new motor lifeboats (MLB), station crews drilled daily, in all kinds of weather, to ensure their proficiency when called upon for a real distress call. This vessel, a 36-foot MLB, was designed to roll completely over and could shed water taken aboard through scuppers in the sides at deck level.

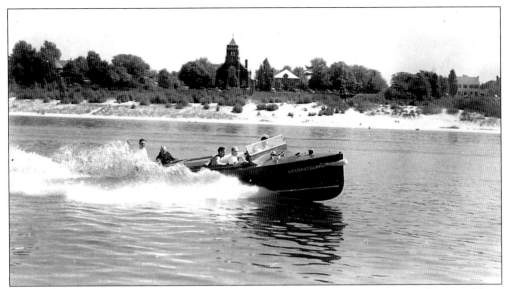

The U.S. Coast Guard also used fast boats to get to the scene of a distress call as quickly as possible. Often, they put confiscated vessels into use.

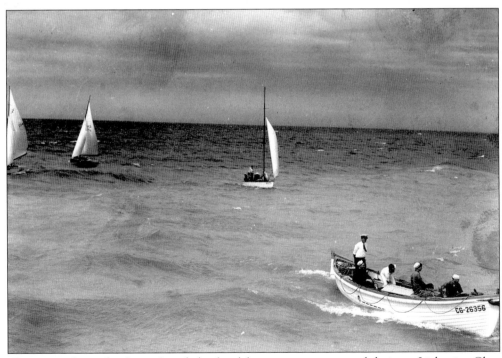

This image shows the Coast Guard chief and four crewmen on patrol during a Lightning Class sailboat race. When South Haven was headquarters for Lightning boats, the U.S. Coast Guard often provided support for the races.

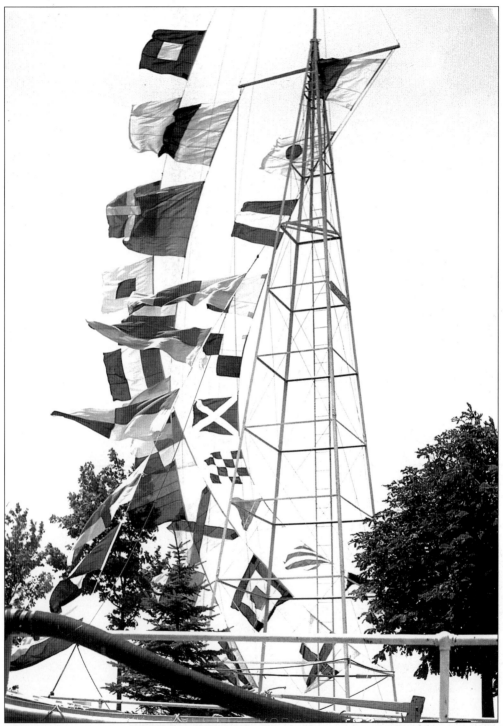

This is the flag tower on the south beach next to the U.S. Coast Guard Station. Numerous flags are flown for special events such as Change of Command or other special occasions calling for the "Rainbow of Colors," which is all of the signal flags flown in a predetermined order.

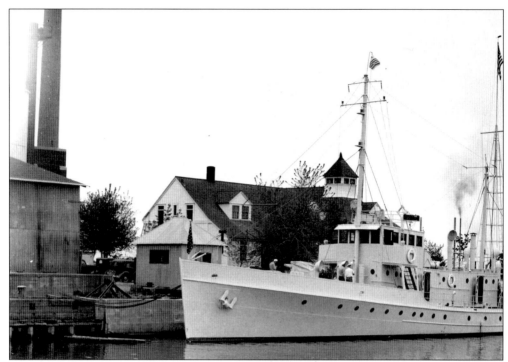

U.S. Coast Guard cutters in the area often stopped in South Haven. This patrol boat may have pulled in due to bad weather or to refill its fresh water or food supplies.

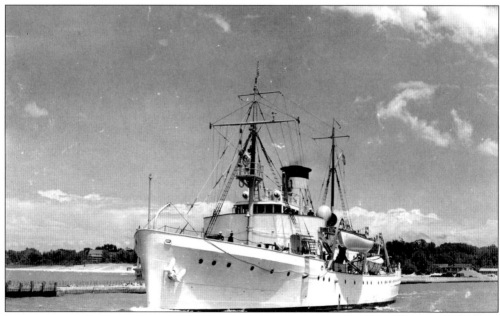

The popular U.S. Coast Guard ice breaker *Escanaba*, homeported in Grand Haven, Michigan, was a frequent visitor to South Haven. The vessel was torpedoed and lost in the North Atlantic during World War II.

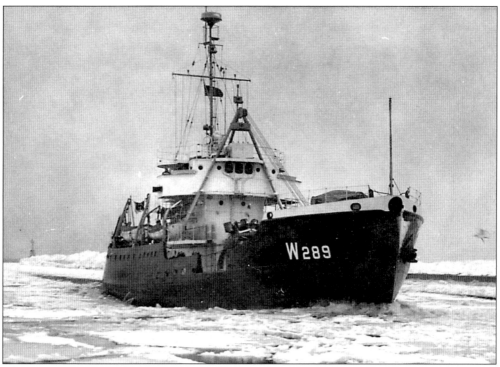

The U.S. Coast Guard icebreaker *Woodbine* (W289) breaks ice in the river. When South Haven was classified as a commercial harbor, icebreakers were often called in to open the channel or assist commercial fishing boats.

A local resident takes a picture of a U.S. Coast Guard icebreaker approaching the harbor.

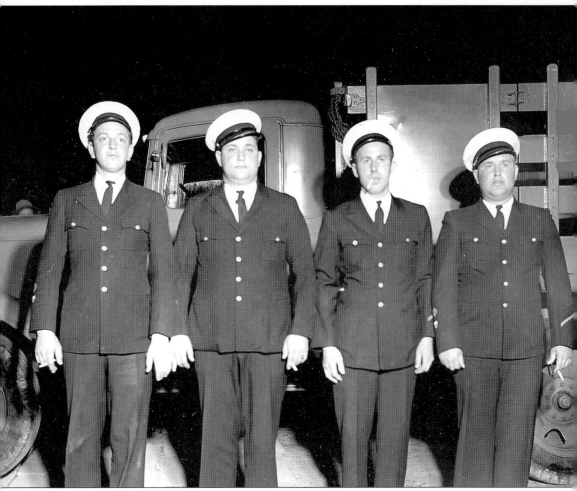

U.S. Coast Guardsmen are pictured in dress uniform. From left to right are Albert Leins, unidentified, Fred Vogel, and Charles Dannison.

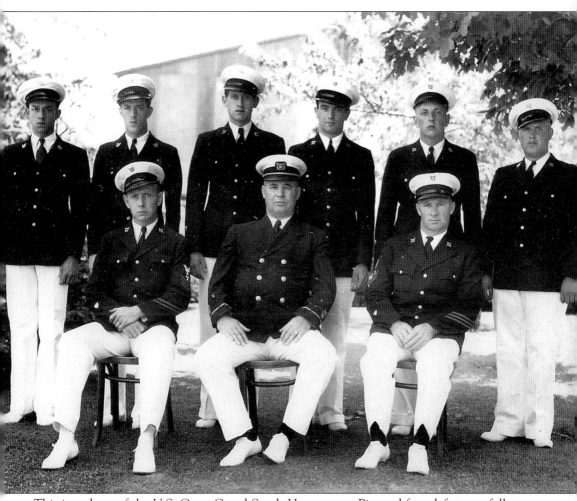

This is a photo of the U.S. Coast Guard South Haven crew. Pictured from left are as follows: (front row) Kenneth Cortright, MoMM 1st class; Captain William Fisher; and Julius Wheeler, BM 1st class; (back row) George Mitchell, Fred Vogel, Albert Bates, George Oudemolen, Morris Allen, and Byron Dannison.

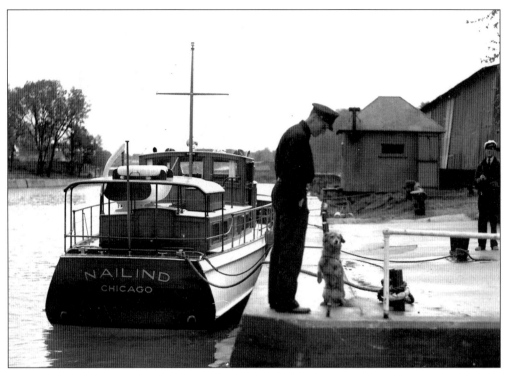

"Coasties" play with a dog near a visiting yacht tied up at the Coast Guard station. It was common to see animals at the various stations. Almost every station had a dog as a mascot, and some even drilled with the men. A number of heroic dogs even helped save lives, which earned them not only recognition, but rank as well.

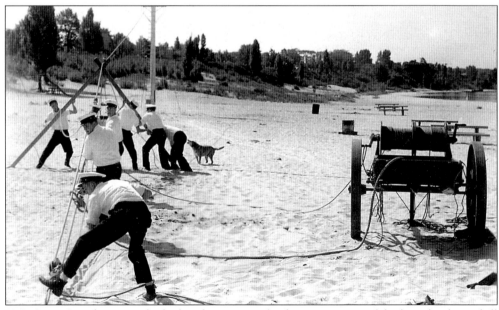

U.S. Coast Guardsmen ready the beach apparatus for demonstrations of the breeches buoy drill at the Fourth of July celebration. The station mascot, Major, seems to be "barking" orders.

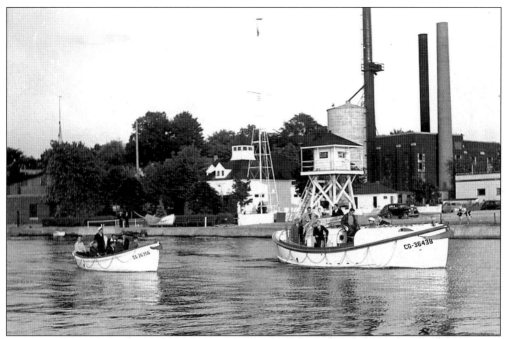

The South Haven U.S. Coast Guard Station is pictured with the 26-foot motor surfboat and 36-foot motor lifeboat, both with civilians on board. Fully restored examples of both of these vessels are on exhibit at the Michigan Maritime Museum.

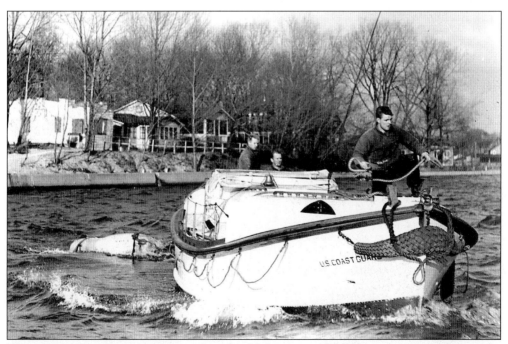

Three Coast Guardsmen are pictured in the 36-foot motor lifeboat preparing to moor at the station. Most 36-foot MLBs had the same bow fender that protects the boat when "nosing" up to a pier or another vessel.

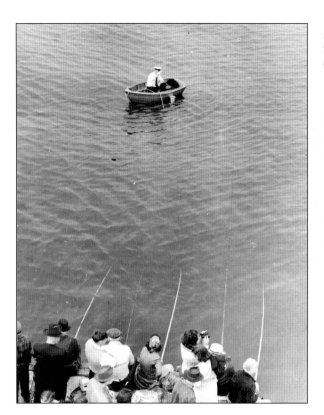

An off-duty Coast Guardsman vies for fresh perch with the fishermen on the pier.

"Coasties" often fished during their off-duty time. These men have caught a fine stringer of perch.

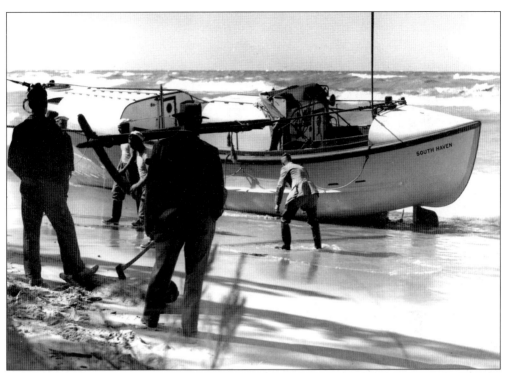

Crewmen work to free the South Haven Station's 36-foot motor lifeboat from grounding on the Lake Michigan beach.

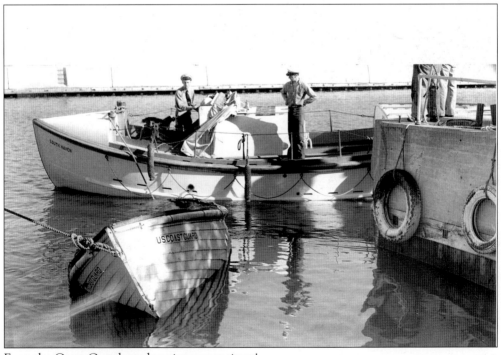

Even the Coast Guard needs assistance at times!

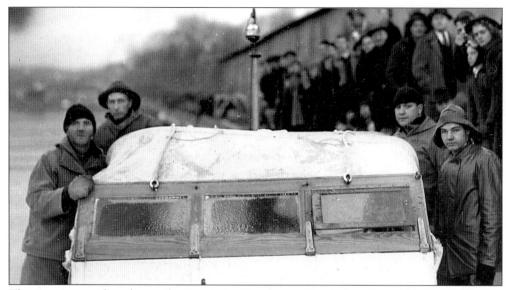

This image was taken during the Armistice Day Storm, November 11 and 12, 1940. The 36-foot MLB and crew, which had gone out in the storm to search for two overdue commercial fishing tugs, were feared lost. After a day-long ordeal, during which the boat rolled completely over several times, it arrived in Chicago, having been unable to return to South Haven. The fish tugs were lost, and this photograph captured the moment of the safe return of the weary Coast Guardsmen the next day.

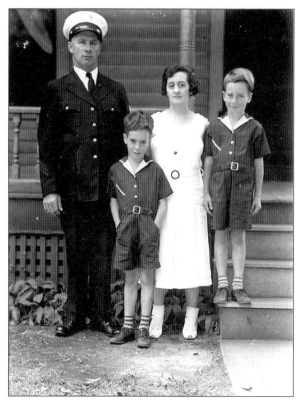

U.S. Coast Guardsman Julius Wheeler is pictured with his family outside the lightkeeper's house in South Haven.

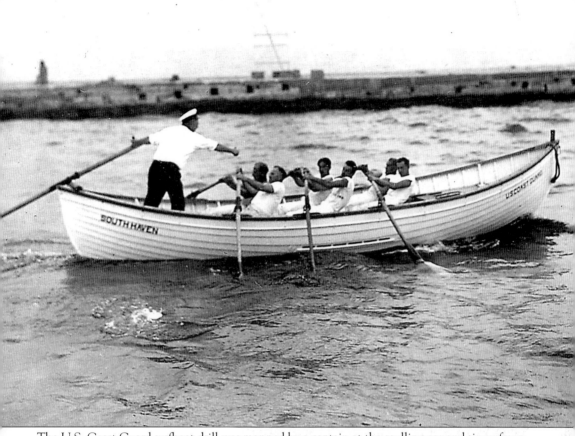

The U.S. Coast Guard surfboat drill was manned by a captain at the sculling oar and six surfmen.

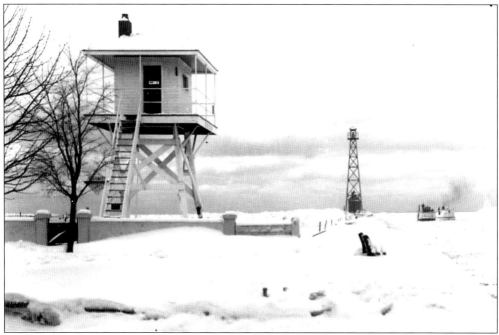

In this winter scene at the Coast Guard Station, two commercial fishing tugs "buck" ice, trying to reach their nets. The station lookout tower at left closed each November and reopened each April.

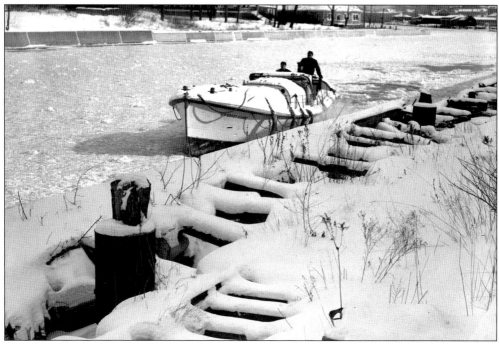

U.S. Coast Guard personnel are seen in the 36-foot motor lifeboat breaking ice near the station. Until the 1970s, the harbor was kept free as long as possible for fishing tugs and other commercial vessels.

U.S. Coast Guardsmen are pictured on the bow of a 36-foot motor lifeboat operating among icebergs.

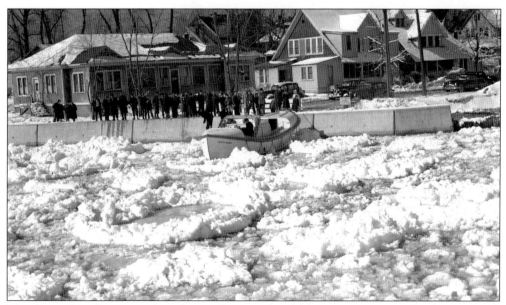

The Coast Guard is pictured on duty with its 36-foot lifeboat in river ice at the foot of North Shore Drive.

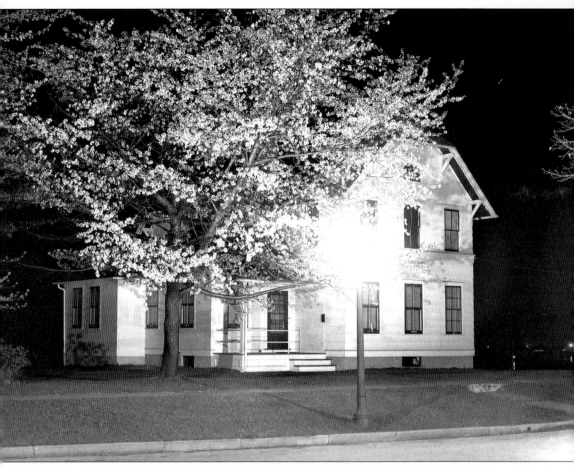

This is a unique nighttime photograph of the lightkeeper's dwelling. The Coast Guard used this house for a while after the Lighthouse Service was integrated. This facility currently houses the Michigan Maritime Museum's Marialyce Canonie Great Lakes Research Library and curatorial operations.

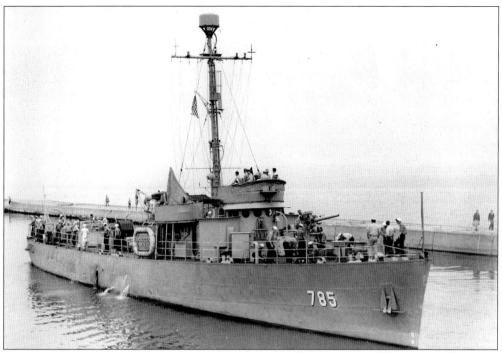
U.S. Naval Vessel No. 785 arrives in South Haven, on maneuvers from the Great Lakes Naval Training Base north of Chicago.

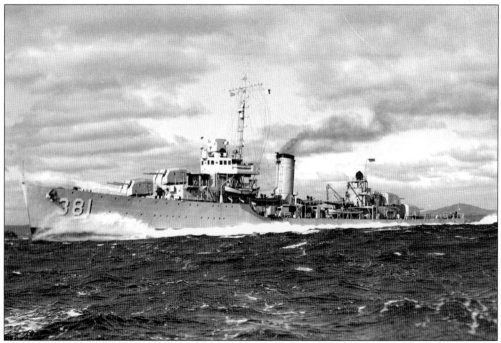
U.S. Naval Vessel No. 381 is pictured off South Haven on maneuvers from Great Lakes Naval Training Base.

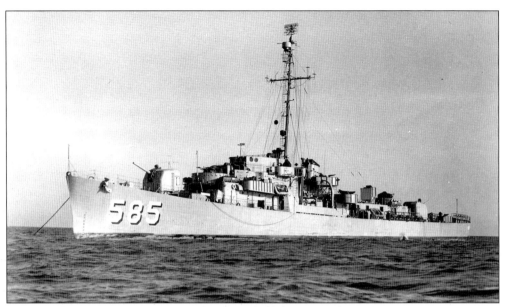
U.S. Naval Vessel No. 585 is pictured anchored off shore on training maneuvers.

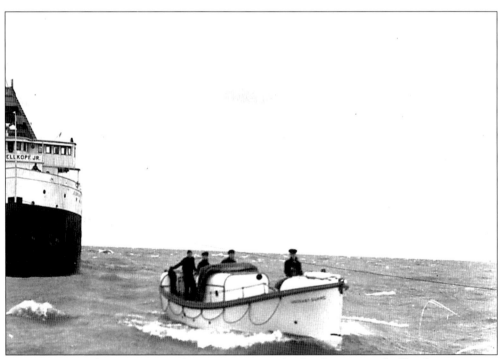
U.S. Coast Guard crew uses a 36-foot MLB to assist the freighter *J.F. Schoellkopf Jr.* into port.

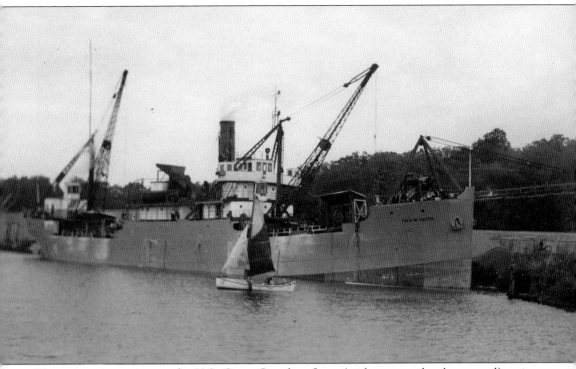

This is a unique picture of a U.S. Coast Guard surfboat (with mast and sail mounted) as it maneuvers in the river near the visiting freighter *Fred W. Green*. The *Green* was built in 1918 at Ecorse, Michigan. Her name was changed to *Craycroft* in 1942. Soon after, a German submarine off Bermuda sank her during World War II.

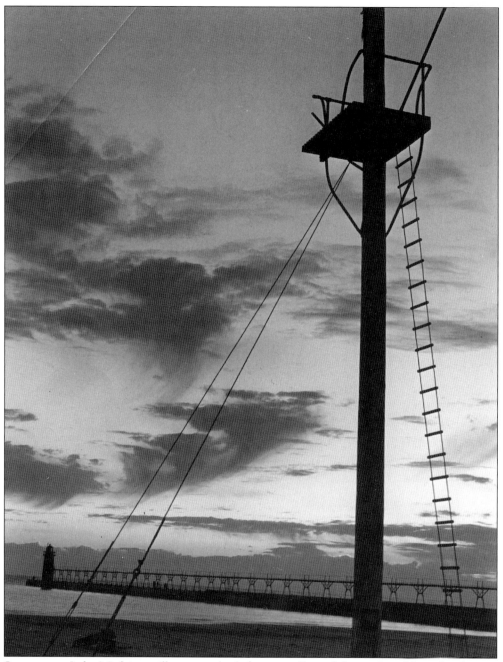

Sunset over Lake Michigan silhouettes the light, catwalk, and Coast Guard breeches buoy drill tower.

Four
RECREATIONAL BOATING

South Haven's harbor today is entirely recreational. But at the beginning of the 20th century, pleasure boats were a minority. While big powerboats grumble their way up the river now, silent sailing craft glided in back then. These early pleasure boats had to be careful in a harbor where up to nine freighters could be looming above them. By the 1950s, commercial traffic had greatly decreased and more slips were available for pleasure craft.

In the early 1900s, the South Haven Yacht Club was one of the few places pleasure boats could dock. In 1902 the first water carnival was held. This included a nighttime illuminated boat parade and a Chicago to South Haven yacht race.

In the 1940s, pleasure yachts such as those made by the Chris-Craft Company were becoming more numerous. In 1942, South Haven hosted the National Lightning Class Regatta for sailboats. These little sailboats were extremely popular in South Haven, as is shown by the many pictures in this chapter.

Today, the harbor hosts a variety of activities throughout the boating season. Harbor Fest, with music and dragon boat races, is celebrated in June. The Michigan Maritime Museum holds a Classic Boat Show. People from all over the Michigan as well as neighboring states flock to South Haven every Fourth of July to witness fireworks over the harbor. There is a Blueberry Festival in August. There are a number of permanent recreational fixtures as well: charter fishing boats, parasailing, dinner cruises, and a floating restaurant. Many condominiums along the Black River offer permanent slips. These venues, along with the fine public beaches, attract many boaters to port.

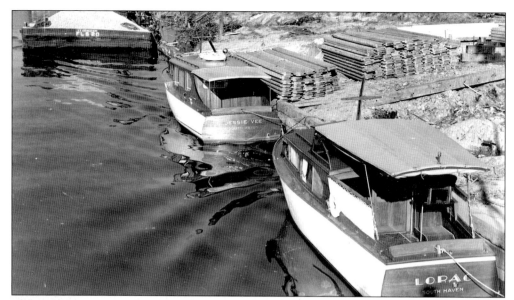

This is a harbor scene looking northeast from the South Haven Yacht Club. Two cabin cruisers, the *Jessie Vee* and *Lorac*, are tied up near a Corps of Engineers barge with a load of stone. A commercial fishing tug is tied up at the South Haven Terminal Company warehouse. This area is the current site of Old Harbor Village and Captain Nichols Fishing Charters.

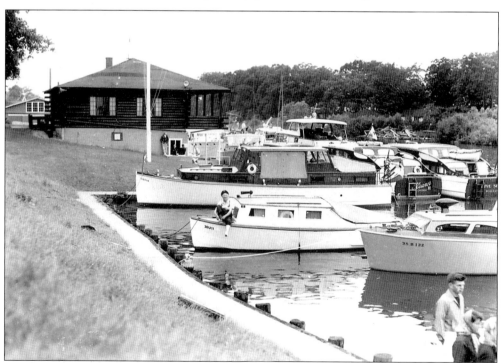

Harry Griffin rests on the bow of his boat at the South Haven Yacht Club. Vessels from the Chicago Yacht Club Power Squadron are at the dock. The Power Squadron competed in a timed race from Chicago to South Haven. A party was held at the Yacht Club for the occasion, before the yachts departed for their various destinations.

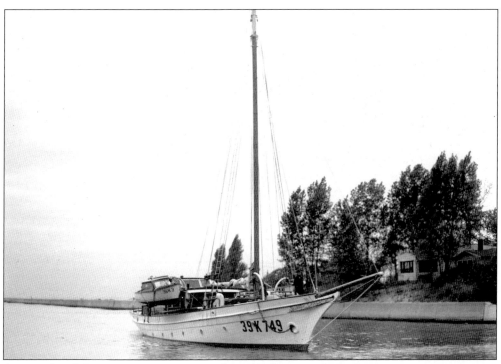
A streamlined sloop, carrying its own tender, quietly enters the harbor.

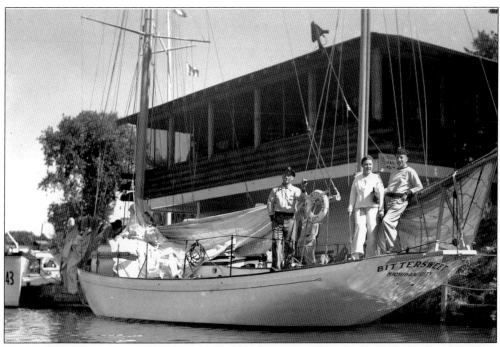
The sailboat *Bittersweet* of Michigan City, Indiana, is pictured visiting the South Haven Yacht Club.

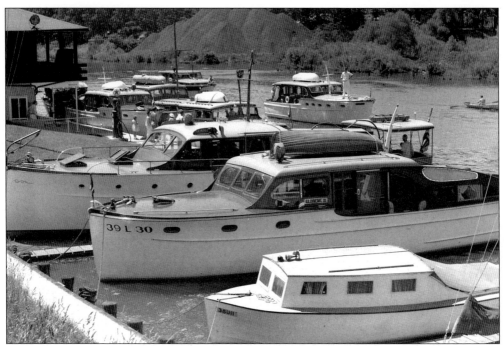

This is an early view of the South Haven Yacht Club docks. Yachts docked abreast in front of the building are from the annual visit of the Chicago Power Squadron. The area across the river where piles of coal are stored is now the South Haven Municipal Marina.

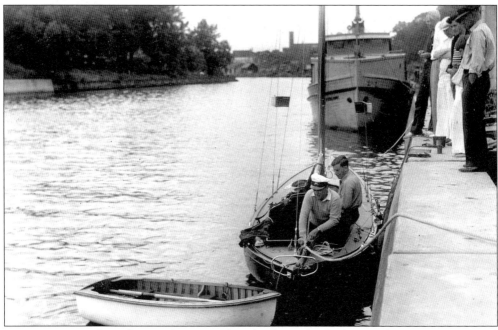

Crewmen secure the sailboat, *Afventyr*, and its dinghy at the docks near the U.S. Coast Guard Station on July 16, 1938. Docked nearby is the Michigan Conservation Department vessel *Patrol No. 1*, on duty in the area to monitor commercial fishing activities.

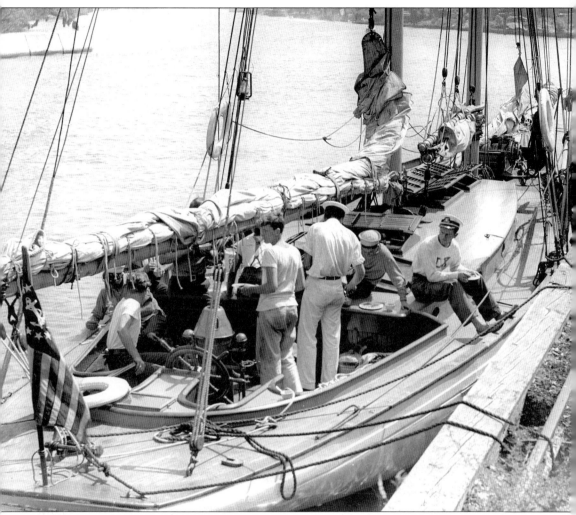

A group of Sea Scouts on a training cruise aboard the schooner *Sea Jay* stop over in South Haven in 1941. Can you spot the box of Cornflakes on the port side of the cabin?

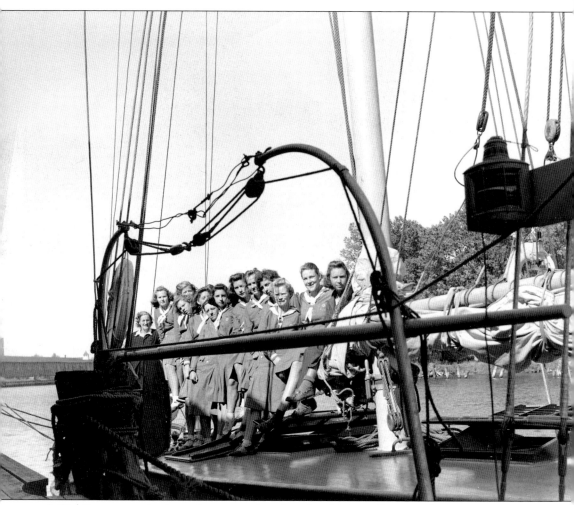
A Girl Scout troop is pictured on an outing aboard a visiting sailing vessel.

This image depicts a water-skiing show on the Black River in front of the South Haven Yacht Club around 1950. This area is now strictly monitored as a no-wake zone. Note the skier isn't using his hands!

Roy McCrimmon is pictured going out with U.S. Coast Guard Chief M. Worth to photograph Lightning boat races in 1949. (Martin Benacker, photographer.)

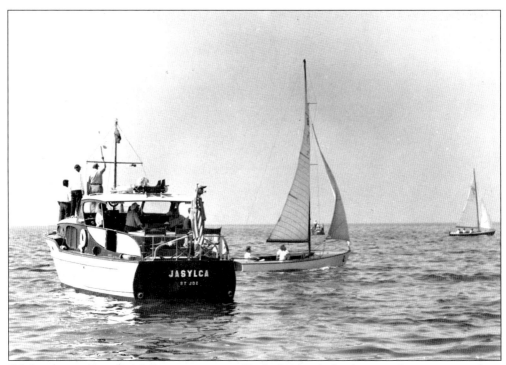

Of this image, Roy S. McCrimmon wrote, "Jack Gardner's *Jasylca* was the committee boat during the three-day regatta—sailed off South Haven July 10, 11, and 12. Jack Nixon is signaling with the flag to the 21 Lightnings that the race is ready to start at 10 a.m. Saturday."

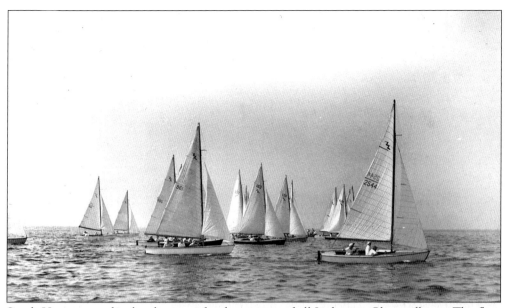

South Haven served as headquarters for the registry of all Lightning Class sailboats. The fleet grew significantly in the 1940s and 1950s.

People in this lone Lightning make quick time in the brisk Lake Michigan breezes.

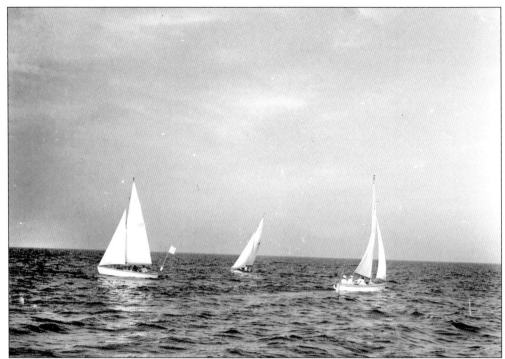

Two Lightnings round the marker buoy during a race; the crew of a third observes while sailing in another direction. Sail No. 340, *Blitzen*, belonged to Norris Johnson (George Hale and William Templeton, crew). The course for Lightning racing was a triangle with one-mile-long legs. The first leg of a race was always upwind. The buoys were usually borrowed from local commercial fishermen.

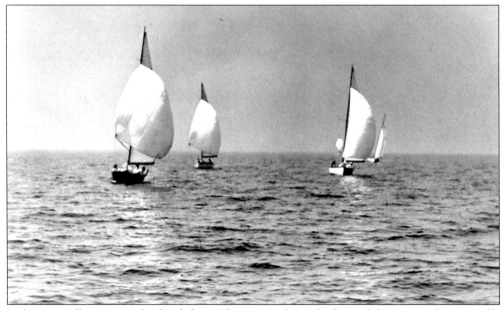

Lightning sailboats near the finish line. They are making the best of their spinnakers, usually used when going downwind.

Two Lightning sailboats fight for the lead in a close race to the finish line. The forward sail is a jib; the after sail is the main sail.

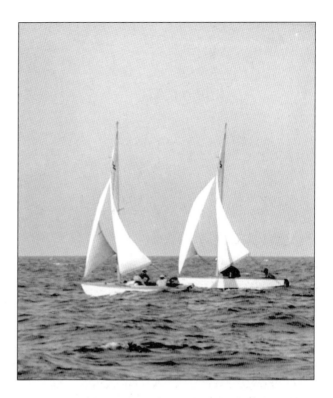

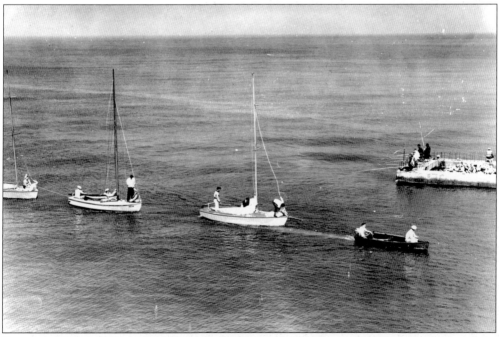

From atop the south pier catwalk, photographer Roy McCrimmon captures the return of the Lightning fleet from the weekly races. South Haven harbor historian Marty Benacker is shown at the tiller of the first Lightning. These vessels were not motorized and had to be towed to and from the race area.

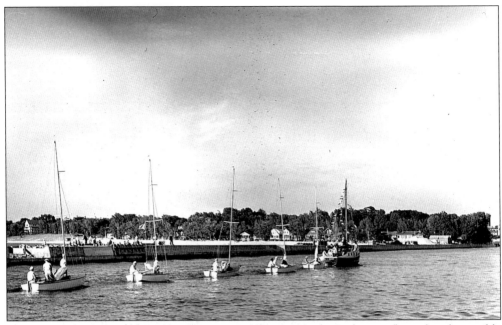

Powerboat and former U.S. Navy launch *Sea Adler* tows in the Lightning fleet after the weekly races. The Lightning craft are numbered 336 through 340 and were the first five in South Haven harbor.

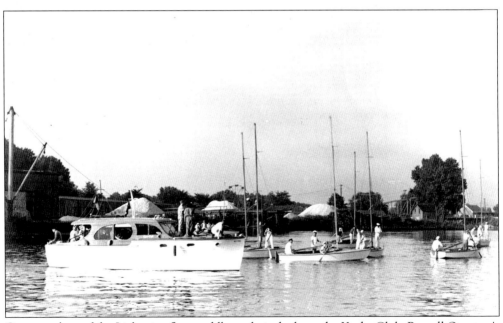

Crewmembers of the Lightning fleet paddle to their docks at the Yacht Club; Russell Overton's nearby cabin cruiser has just towed them in. In the background (at the current site of the Michigan Maritime Museum) sit piles of gravel and a Ferris wheel.

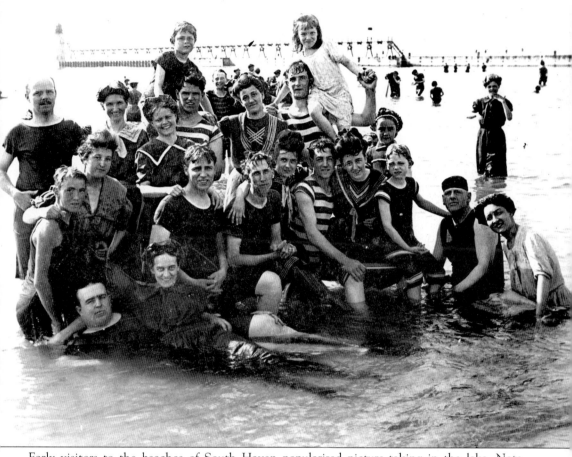

Early visitors to the beaches of South Haven popularized picture-taking in the lake. Note another photographer in the water with a tripod, taking a picture of another group.

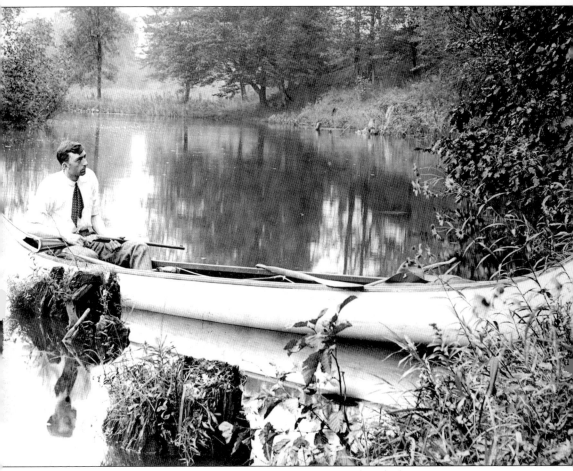
This is a beautiful, reflective portrait of a hunter going up the Black River in a canoe.

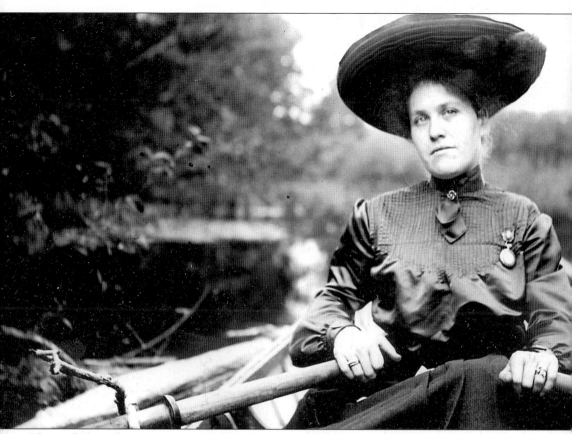
This well-dressed woman appears to know how to row a boat competently.

Observers on the north pier watch the Lightning races at sunset.

Five
COMMERCIAL FISHING

Fishing provided a living for numerous families in South Haven in the early 20th century. It was hard work, subject to the whims of the weather and Mother Nature. When all other maritime activities had ceased for the winter, the fish tugs still attempted to get out each day, bucking the ice.

The daily routine on a fish tug began early in the morning. With a crew of three to five men, the tug would head for the open waters of the lake to find their buoys, which would indicate where they had left their nets. Usually they did not venture more than 30 miles from their home port, and they would return each evening. When the buoy was found, work would commence. First, the gill nets would be hauled in. These nets would stretch for miles on the lake bottom, catching fish that tried to swim through the mesh. As the nets were winched aboard, crewmen would pick out the fish and throw them into boxes of ice. When this task was finished, the men would either pay the nets back out, or they would be taken back to the fishery for repair. After the nets and buoys had all been set, the men would get to work cleaning their catch as they headed for home. Whitefish, chubs, and perch were the most common of the fish caught.

The fish tug was a hardy boat. Earliest ones were built of wood, and often had a steel reinforced hull to help with the ice in winter. The deck was covered to shelter the men while they worked. Later, tugs were built completely of steel.

Five to seven tugs worked out of South Haven in the 1920s–1940s. Commercial fishing continued into the 1960s. The Lamprey eel and governmental regulation eventually eliminated commercial fishing here.

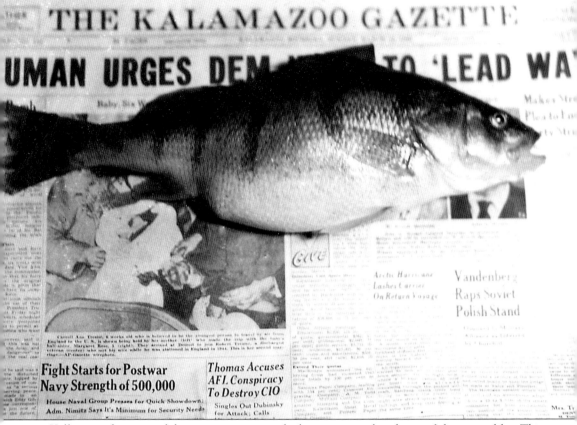
Yellow perch is one of the main species sought by commercial and sport fishermen alike. This good-sized specimen is nearly the width of a 1940s newspaper page.

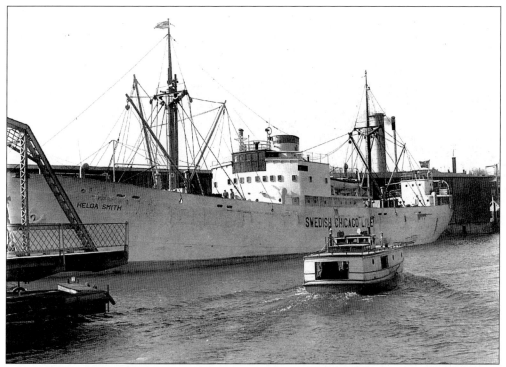

Commercial fishing and shipping shared South Haven harbor from the 1920s through the 1960s. Here, Glen Richter's fish tug *Butch LaFond*, which docked above the bridge, clears the old Dyckman Avenue swing bridge. The tug passes the Swedish paper pulp ship *Helga Smith*, a frequent visitor to South Haven.

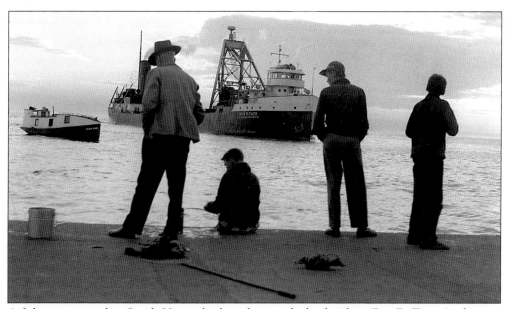

A fish tug approaches South Haven harbor along with the freighter *Ben E. Tate*. As this was a common occurrence in the 1930s and 1940s, fishermen on the pier seem unconcerned by the activity.

Fred Balow owned the *B&B*. It is seen tied up at the subsequent site of the Jensen Fishery. On November 12, 1925, the *B&B* suffered a severe fire after being docked for the night.

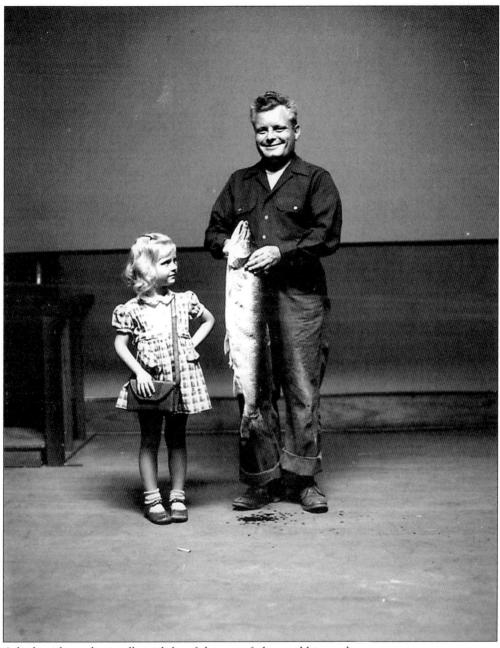
A little girl stands proudly with her fisherman father and his catch.

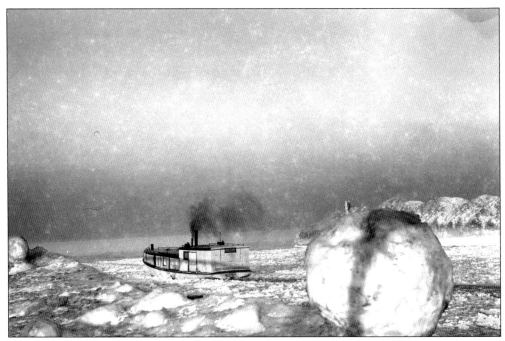

The wooden fish tug *Buddy O.*, of the Jensen Fishery, passes large ice formations as she nears open water off the end of the South Haven piers in the early 1940s.

Commercial fishermen Glen Richter, Frank Richter (his father), and A.C. Willis are pictured on top of the iced-over tug *Buddy O*. The *Buddy O.* was built by Sturgeon Bay Boat Works for Ole Olsen of Frankfort, Michigan, in 1935. (Ray Wakild Collection, Michigan Maritime Museum.)

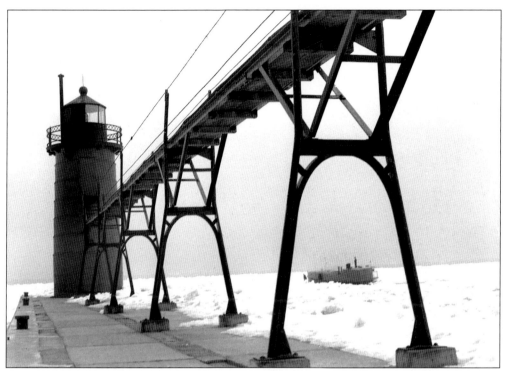

Commercial fishermen contemplate their situation, walking around two fish tugs stuck in ice floes off of the south pier. Why are there so many images of fish tugs in ice? During good weather, the vessels were far out on the lake tending their nets.

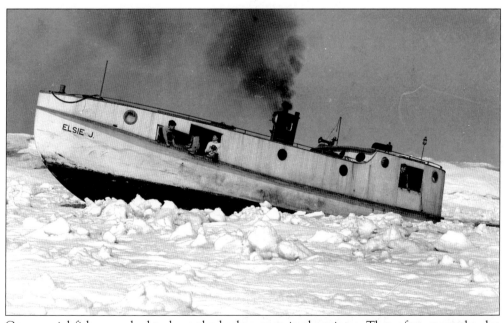

Commercial fishermen had to keep the harbor open in the winter. They often spent the day "bucking" ice without ever reaching open water. Such was the case on the steel Jensen tug *Elsie J.*, with Julius Allers at the wheel and children David and Paula along for the ride.

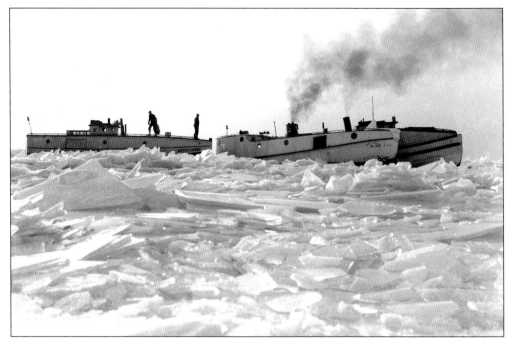

In 1947, the fish tugs *Butch LaFond*, *Elsie J.*, and *Buick* found themselves stuck fast in ice off the South Haven piers. Working together, they made it safely to port after spending the night on the lake.

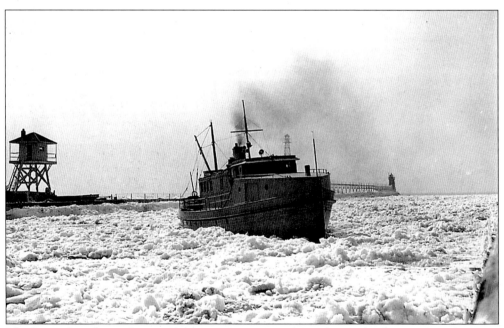

The State of Michigan Conservation Department vessel *Patrol No. 1* bucks ice in South Haven harbor. Homeported in Charlevoix, Michigan, the patrol boat monitored commercial fishing in the upper Great Lakes. Duties included checking for legally sized nets, seasonal fishing, and fish sizes. Charles Allers was its only captain during 30 years of service, from 1929 to 1959.

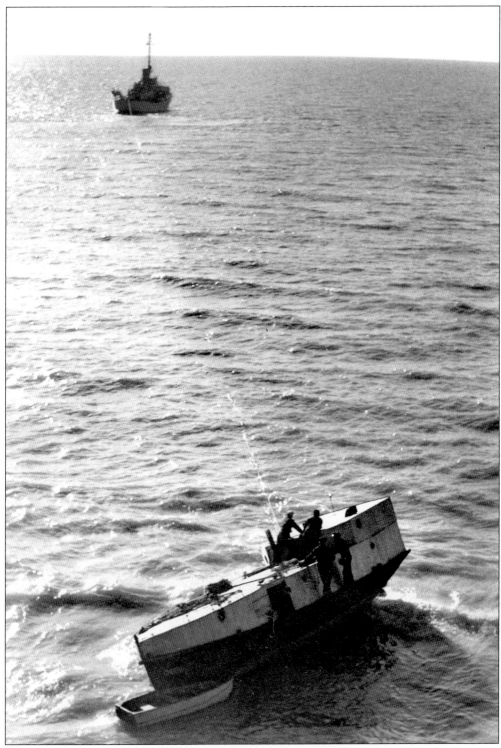
Commercial fishermen faced numerous hardships. Here a U.S. Coast Guard vessel attempts to pull the fish tug *Cheerio* to deeper water.

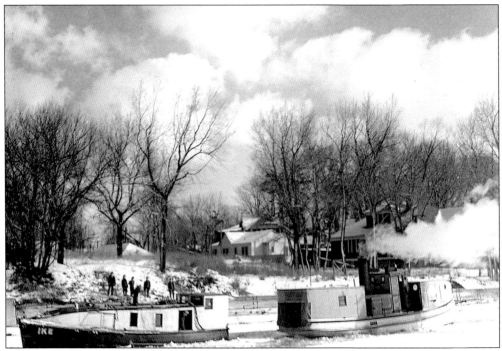

In this rare image of the steam tug *Richard H.*, it is shown assisting the Jensen tug *Ike*, disabled in river ice. The *Richard H.* and another fish tug, *Indian*, were lost in the great Armistice Day Storm on November 11, 1940.

Local fisherman Chris Jensen is pictured putting gill nets onto a reel for drying and repair, if needed.

Chuck Jensen and his father, Chris, examine part of the roof from the fish tug *Indian*. Wreckage from the lost tugs was found from Grand Haven to Pentwater. (Ray Wakild Collection, Michigan Maritime Museum.)

Chuck Jensen lifts the pilothouse roof from the commercial fishing tug *Indian*, which was lost with all hands in the Armistice Day Storm. (Ray Wakild Collection, Michigan Maritime Museum.)

Fisherman Chris Wakild is pictured on the fishery docks near the Dyckman Avenue Bridge. Captain Wakild and crew were lost on the fish tug *Indian* in the 1940 Armistice Day Storm. (Ray Wakild Collection, Michigan Maritime Museum.)

Six

South Haven Light and Piers

In 1868, the U.S. Lighthouse Board requested an appropriation of $6,000 for the construction of a pierhead beacon and lightkeeper's dwelling for South Haven. The following year, a site on a nearby bluff was selected for the keeper's dwelling. Due to a shortfall in the federal budget, monies were not made available until 1871. Construction began that year. The original beacon was a 30-foot wooden structure, with a 75-foot wooden catwalk for easier access in bad weather. The first lightkeeper, W.P. Bryan, arrived in 1872. There were six keepers who lived in South Haven: Bryan, James Donahue, Louis Deimar, Jesse T. Brown, John Langland, and the last, Robert Young, who served until 1940, when the responsibilities were relegated to the U.S. Coast Guard.

In 1901, both the north and south piers were extended and the light was moved 249 feet to the new end of the south pier. The catwalk was extended as well. Locals refer to this addition point on the pier as "first." In 1902, a new fifth order Fresnel lens was installed. The previous light had been a gasoline burner. The following year, the wooden beacon was replaced with a 35-foot steel structure that was brought by the lighthouse tender *Hyacinth*. Another extension of the piers occurred in 1913 and the light was again moved 425 feet to the new end. Locals refer to the starting point of this addition as "second." An automated fog bell was installed on the lake ward face of the tower at this time as well. Before the automated bell, it was the responsibility of the lightkeeper to blow a foghorn.

In 1916, a 50-foot steel range light tower was built 800 feet shoreward of the pier light. In 1925, the catwalk was changed to steel. The lighthouse tender *Sumac* brought the new one from Calumet Station. The fog bell was replaced by an air-powered horn in 1937. In 1940, the south pier was made concrete.

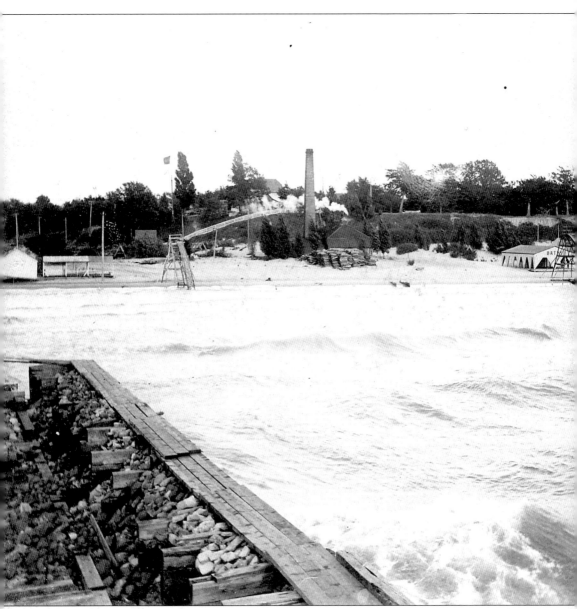

This image shows South Beach pre-1910. The pier, at left, was constructed of timber cribs and pilings filled with stone. Beach visitors used the two slides and large bathhouse.

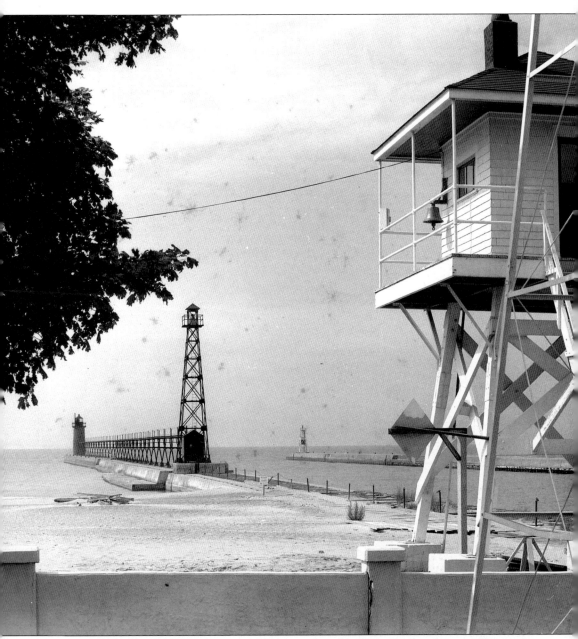

This image shows South Haven piers as they appeared in the 1940s. By this the time, the south pierhead light had been painted red, per the navigational adage "red, right, return" (to port). Mariners approaching the port used the range tower at the base of the south pier. Alignment between the light and range tower assured safe entry. At right is the U.S. Coast Guard lookout tower. Crewmen on duty rang the bell at specified hours day and night. Marty Benacker commented, "The kids knew when to go home by the rings of the bell."

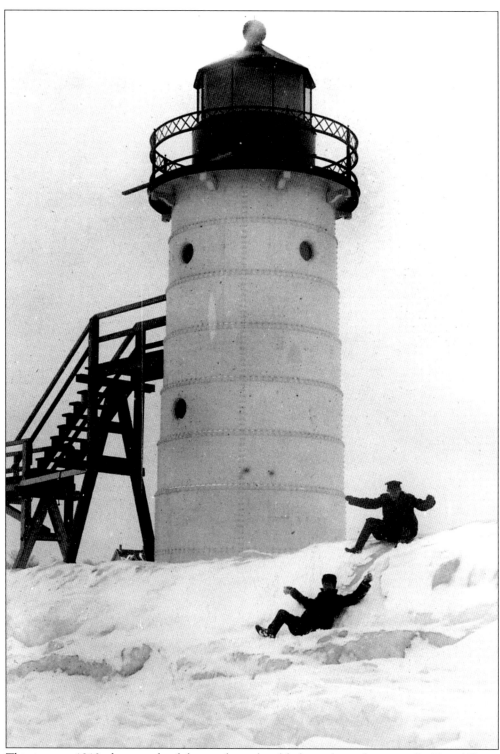
This is a pre-1913 photograph of the south pierhead light and wooden catwalk. Two fellows, perhaps U.S. Life-Saving Service crewmen, make the best of a long winter.

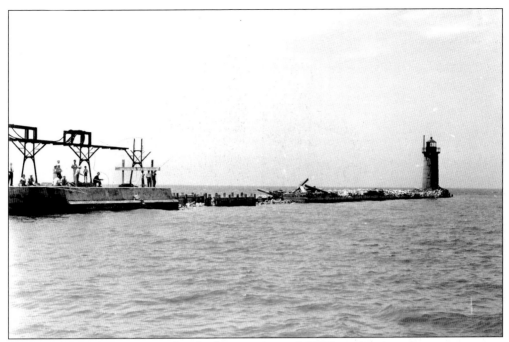

In 1940, the south pier received its final extension, to 1,200 feet.

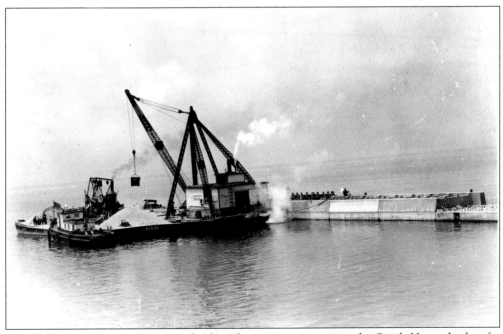

Corps of Engineers tugs, barges, and a derrick crane are present in the South Haven harbor for north pier improvements.

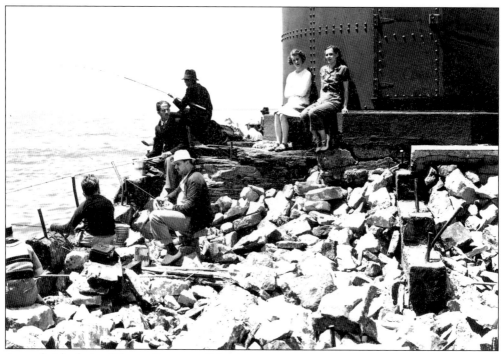
An unfinished pier did not discourage fishermen.

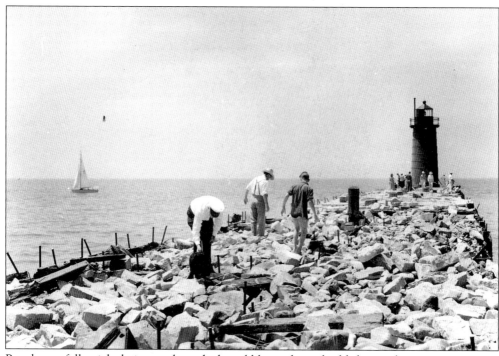
People carefully pick their way through the rubble used to rebuild the south pier.

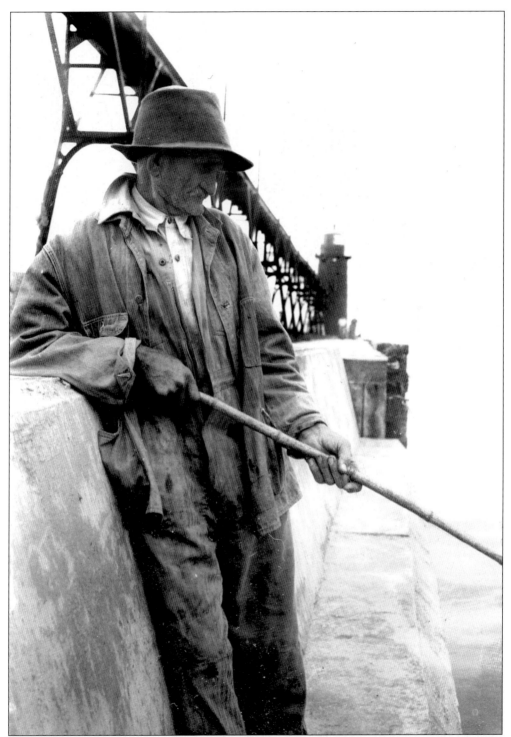

The piers attracted many people for fishing. For 10¢ a day, one could rent a cane pole from Jack's Place, where bait was also available. Mr. McCrimmon made a note that this gentleman wasn't aware that his photograph was being taken.

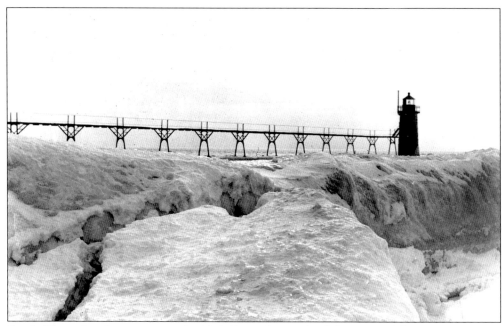

South Haven beaches are covered with icebergs for much of the winter. This one appears to envelop the north pier.

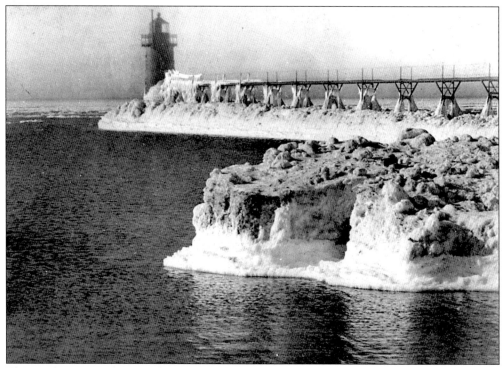

The south pier can be quite beautiful in winter, when the catwalk and light become coated with ice.

Before South Haven had a high school with a pool, swimming lessons were provided on the south beach and pier. The concrete foundation at right was a former location of the light.

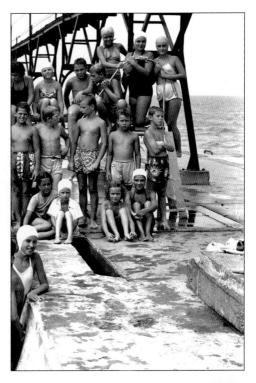

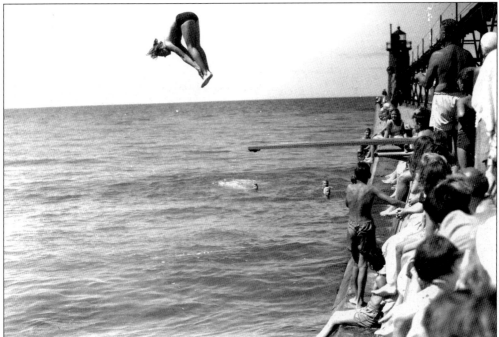

The south pier was opened for swimming only at certain times of the day. The area, about midway to the end of the pier, was known locally as "second." A diving board was mounted on the foundation that formerly held the light. Today, the Corps of Engineers has placed large boulders along the piers and diving is prohibited.

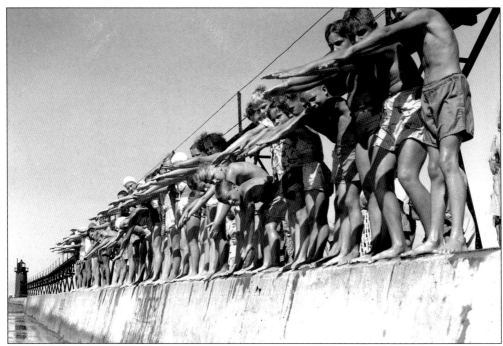
Taking the plunge: ready, set, go! In reality, the children are merely posing for the photograph. The lower part of the pier in front of them is concrete, popularly called "first."

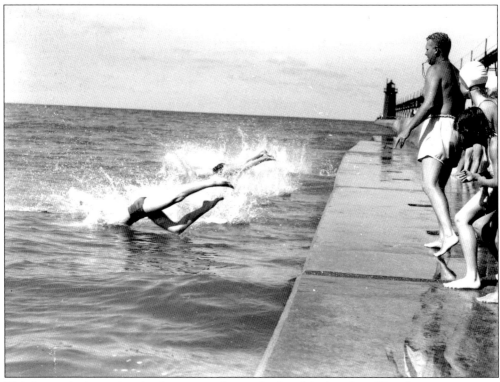
This image depicts swimming lessons on the south pier, this time from "first."

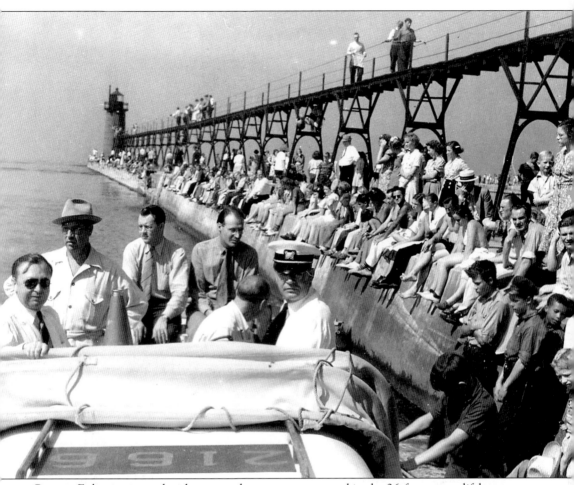
Captain Fisher is pictured with crew and passengers on patrol in the 36-foot motor lifeboat near the south pier. Crowds on the pier suggest a notable event or even an accident.

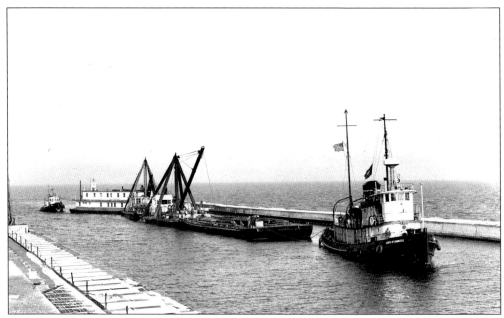

In this image, barges with steel plating for the piers, derricks, and crew barracks are being towed into South Haven harbor. The larger tug was used for larger moves, such as those from port to port, while the smaller one stayed to maneuver the equipment in the harbor.

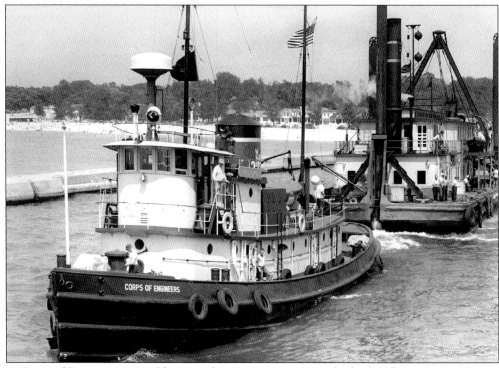

A Corps of Engineers tug and barge with crew quarters are in the harbor for pier maintenance in the 1950s.

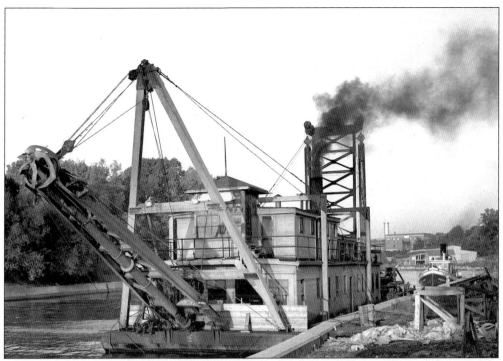

This is one of the early dredges used to keep the harbor bottom deep enough for commercial vessels.

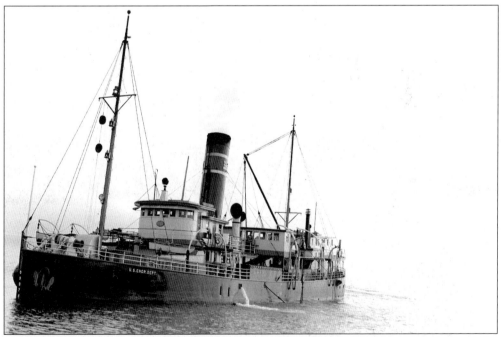

This Corps of Engineers dredge, sometimes referred to as a "sand-sucker," works around the mouth of the South Haven harbor, deepening it for commercial navigation. Materials dredged from the river and harbor mouth were dumped in deeper waters offshore.

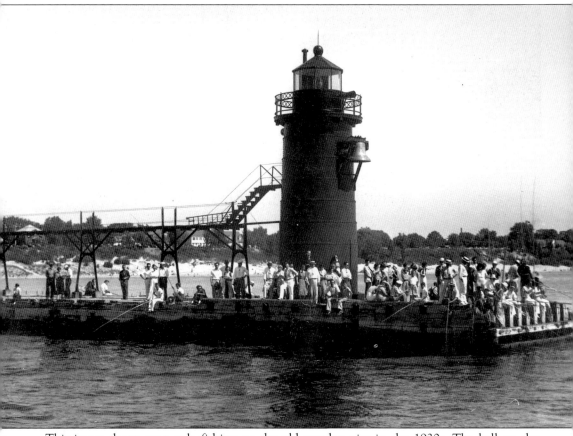
This image shows cane pole fishing on the old wooden pier in the 1930s. The bell on the lighthouse was used as a fog signal before automated horns.

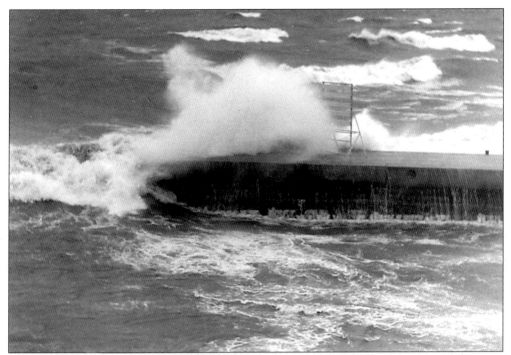

The Great Lakes are hard on navigational aids. At least four different types have been placed on the north pier. The marker shown here was used to reflect a spotlight from the south pierhead light to aid approaching vessels.

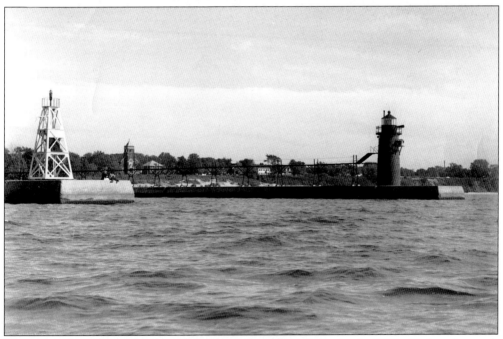

This image shows South Haven north and south pierhead lights in the 1950s. Today, the north light has been replaced with a reflective spindle and both piers are sheathed in steel.

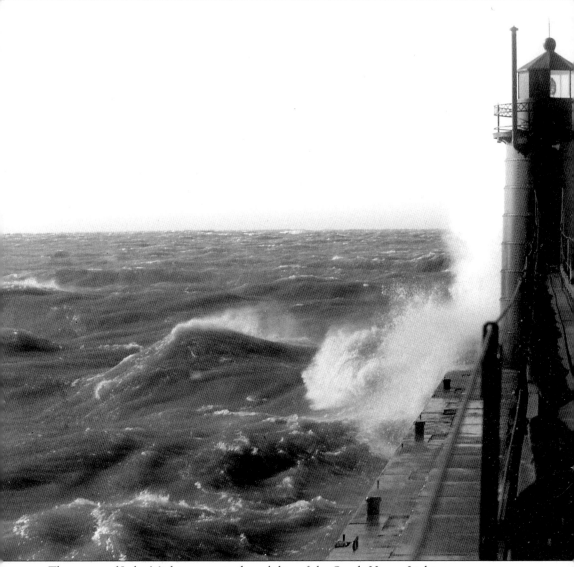
The power of Lake Michigan meets the solidity of the South Haven Light.

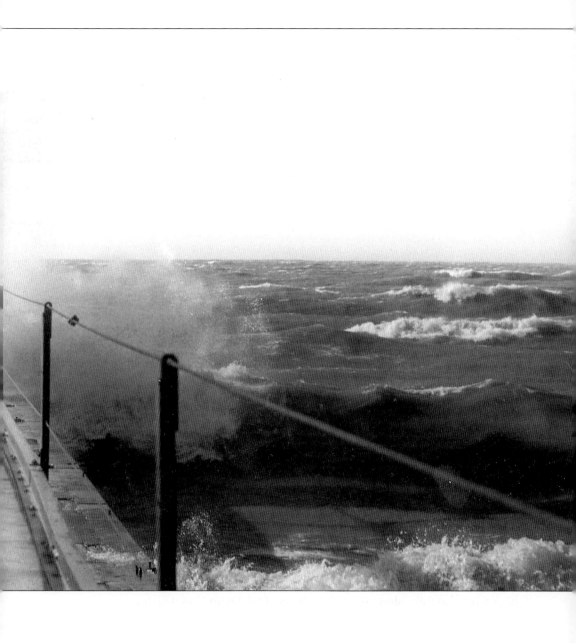

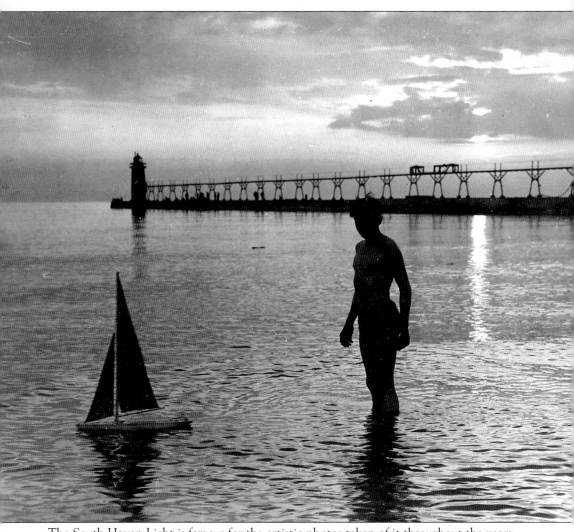
The South Haven Light is famous for the artistic photos taken of it throughout the years.